CONVICT TATTOOS

MARKED MEN AND WOMEN OF AUSTRALIA

Written and illustrated by
SIMON BARNARD

TEXT PUBLISHING MELBOURNE AUSTRALIA

The Text Publishing Company
Swann House
22 William Street
Melbourne Victoria 3000
Australia

textpublishing.com.au
simonbarnard.com.au

First published in Australia by The Text Publishing Company, 2016

Jackct and text design by Simon Barnard
Index by George Thomas
Printed and bound in China by Everbest

National Library of Australia Cataloguing-in-Publication entry
Creator: Barnard, Simon, author, illustrator.
Title: Convict tattoos : marked men and women of Australia / by Simon
Barnard ; illustrated by Simon Barnard.
ISBN: 9781925240399 (hardback)
ISBN: 9781925410235 (ebook)
Subjects: Tattooing—Australia—History.
Tattooing—Australia—Pictorial works.
Tattoœd people—Australia—History.
Convicts—Australia.
Dewey Number: 391.650994

For Amélie

CONTENTS

BODY LANGUAGE

Between 1788 and 1868, approximately 166,000 convicts were transported to Australia. The majority were men from the working classes of England, Scotland and Ireland. Typically charged with theft and sentenced to seven or fourteen year terms, they brought with them their own cultural practices, including singing and dancing, and tattooing.

Convicts made up a large proportion of the British community in the early days of colonisation— in 1820, convicts constituted ninety per cent of the white population, and by 1840 about fifty per cent. At least thirty-seven per cent of male convicts and fifteen per cent of female convicts were tattooed by the time they arrived in the penal colonies; it is most likely that Australia had the world's most heavily tattooed English-speaking population in the nineteenth century.

And because the convicts arrived already bearing tattoos, tattooing could be considered the first non-Aboriginal artform to be introduced to Australia.

Names and initials were the most popular tattoos, but convicts also bore trial dates, birth dates and other personal information. William Sutton, a tailor, was tattooed with his initials, the year of his conviction and the tools of his profession: 'Tailors Sleeveboard Goose Scissors & Bodkin'. Most tattoos were symbolic, expressing love or hope, religious beliefs or patriotic sentiments. John Turner was tattooed with a heart, an anchor, a crucifix and Britannia. Tattoos also expressed sorrow, humour, regret, defiance and allegiance. Margaret Fulford was tattooed with the propitious words: 'Love & Liberty'. William Gilby bore the more mindful: 'William Gilby shun bad Company'. For many convicts, tattoos were simply decoration.

The colonial authorities recorded the convicts' physical features and personal information when they arrived in the colony, primarily as a means of identification and as a record of their trades and skills. But the process was imperfect. John Perryman was tattooed with 'JB AB HB MB', which suggests that his last name was Berryman, that his tattoos represented family members, and that his surname was misheard when his details were recorded. Henry Treadwell claimed he was unmarried and without children, but the ring tattooed on his left hand and the woman and girl tattooed on his left arm suggest otherwise.

Tattoos provide a glimpse of the lives of the people behind the historical record, revealing something of their thoughts, feelings and experiences—their humanity.

The information in this book comes in part from the records of 6806 men transported to Van Diemen's Land between 1823 and 1853, and 3374 women transported between 1826 and 1853. One transport ship was chosen for each of these years, and the physical descriptions of all the convicts on board were examined, and their tattoo records collated and analysed. Men were more heavily tattooed than women and with a greater array of imagery. The tattoos of other convicts were also scrutinised, giving an indication of the possible stories behind many of the tattoos, and the relationship between tattoo and bearer. Five hundred women with a history of prostitution were looked at, along with 238 widowed convicts, 155 executed convicts, convicts who had their death sentences commuted, convicts with histories of gang affiliation and convicts who absconded, among others.

Portraits of convicts that appear in this book have been illustrated from their physical descriptions and overlaid on records replicating the originals.

ISAAC COMER'S YARD

In July 1871, Isaac Comer, aged sixty-one, was marched into the Van Diemen's Land Supreme Court to stand trial for stealing gardening tools. Comer was no stranger to the bench. In his hometown of Bath, England, he'd served five months for assault and six months for stealing a pig. He was also a disgraced soldier, court-martialled for drunkenness. When, in April 1844, Comer was charged with 'receiving stolen goods', he was sentenced to fourteen years' transportation to Van Diemen's Land.

A person's criminal history was integral to the sentencing process. In preparation for Comer's 1871 court appearance, a clerk would have leafed through a series of leather-bound ledgers until he found the entries detailing Comer. Though Comer stood quietly in the dock, his record screamed a spectacular secret: beneath his modest attire Comer's body was so heavily tattooed he may have been Australia's most tattooed man. His gobsmacking collection was such a revelation that the following day a rundown was printed in the local paper.

A cross-check with the records reveals even more. The last line in Comer's tattoo description reads 'seven stars, two rings, and an anchor between legs—on his yard'. The term 'yard' was colonial parlance for penis. Nineteenth-century sensibilities prevented the clerk from writing the anatomical word in official documents and the *Mercury* editor from printing it in the newspaper.

Isaac Comer, on trial in Hobart Town.
Isaac Comer's description in the Mercury, 5 July 1871.

TATOOING.—Yesterday a prisoner named Isaac Comer, who has a string of convictions against his name quite appalling, but who after a long prison life has been at liberty since 1857, has his body nearly covered wiih marks indelibly tatooed into the skin. The following almost incredible list of such marks should, we imagine, leave no doubt as to his identity should he at any future time be required:— On his right arm—Man smoking a pipe; S.C; woman with glass; Jane Bell; woman and man smoking a pipe; R.C.; glass and jug on table; man; C.C.; sundry stars; a half moon; man and woman hand in hand; sun, woman with glass; W.M.; woman with glass; mermaid and sun. On the back of his right hand—Anchor; crucifixion; J.B.; J.C.; and 7 stars. A ring on the middle finger of right hand. On his left arm—Highlander; man with hat in his hand arm-in-arm with a woman; B.J.C.; blue square; turkey-fowl; sun; J.C.; J.B.; crown; anchor (upside down); crucifix; anchor; sun; woman: crucifixion; sun; half-moon; 9 dots; heart and darts; and shears. Bracelet on left wrist; 21 dots; 7 stars; anchor; 5 hearts; A.J.B.; and sun on back of left hand. Ring on each finger of left hand. On his breast—Ship; mermaid; hull of a ship; 2 men sparring. On his right thigh—Woman; 7 stars; crucifixion; sun and moon. On his left thigh—Man smoking a pipe; mermaid with comb and looking glass; 7 stars; a woman with dove in her hand; man hanging from a gallows; man and ladder. There is also a ring round belly. Seven stars; 2 rings; and anchor inside his legs, besides marks on other parts of his body.

THE MAN WHO HANGED HIS WIFE.—Last week as a whole barge full of mourners at the late Dr. Dawson's funeral were returning from Franklin to Iron Stone Creek, on their way homewards, the attention of one of the many Hobart Town visitors was called by a Huon passenger to a figure sitting

THE BLACK BOOKS

The Black Books were registers of the convict populace. Standard entries listed each convict's name, crime, sentence, trade, literacy, religion, height and age, along with a description of their complexion, head, hair, whiskers, visage, forehead, eyebrows, eyes, nose, mouth, chin and any other noticeable oddities, including tattoos.

Until the introduction of photography in the early 1850s, anthropological classification was primarily limited to description. The result was a stunning collection of intimate detail in the Black Books and an unprecedented amount of paperwork. By the 1830s there was more information detailing Van Diemonian convicts than any other group of people on the planet. Thus we know that Isaac Comer was five foot, eleven and a half inches tall with dark brown eyes, a ruddy complexion and a tattooed 'yard'. His tattoos were so extensive that the clerk resorted to writing them vertically over the preceding entries.

Clerks tasked with record-keeping were plucked from the convict ranks. Their position in the Colonial Secretary's Office gave them a certain level of power, something they could abuse. When Douglas Gilchrist and Henry Cockerell were caught reducing a mate's prison term from life to seven years in the Black Books they were packed off to labour at the desolate Maria Island Penal Station.

Record keeping was no easy task. Convict Edward Cook reputedly toiled for fifteen hours a day. He painstakingly wrote some 12,305 entries in a single year and later claimed the ordeal had greatly injured his health. Comer would have been a most unwelcome spectacle. Newly arrived convicts were stripped bare for gruelling interviews and inspections. They were described and recorded in a systematic manner. Writing in nineteenth-century copperplate, however, presented several problems: it took up a lot of space; it was time consuming and it was difficult to rectify mistakes and sometimes hard to read. The J.B. and J.C. tattooed onto the back of Comer's hands and on his left arm that were recounted in the paper are, upon careful inspection, recorded as J.B and I.C. The initials are probably an abbreviation of his own name and a loved one, Jane Bell, whose full name appeared on his right arm.

Clerks adopted a shorthand. Robert Fribbens had an 'anchor etc on left arm' and Edward Brown's tattoos were recorded in what appears to be an indecipherable jumble: 'Woman Child E.B.L.B above E. Jt. left arm'. The sequence is a common contraction used for tattoo description; it possibly represents Brown's wife, Elizabeth, with one of their children, their initials and the tattoos' location above the elbow joint on his left arm. In rare instances the transcriber simply drew the tattoo. James Currie's record appears to feature a Union Jack but the strange doodle on Robert Blair's record almost defies description. Having Blair explain his tattoo may have been enlightening, however the authorities were not concerned with what tattoos represented but how they could be catalogued.

Convicts without tattoos posed a challenge. Clerks were obliged to describe bite marks, broken bones, burns, dimples, freckles, hairs, lost limbs, missing teeth, moles, phlebotomy blotches, pimples, pockmarks, scars, tumours, warts, wounds and wrinkles to provide a distinguishing record. In some instances the subject was so startlingly plain that the entry for 'remarks' simply read 'none'.

Isaac Comer's entry in the Black Books was so extensive his tattoo description had to be written crossways over the preceding entries.

NAMES Collins Robert **No.**

Trade
Height (without shoes)
Age
Complexion Sallow
Head Long
Hair Brown to Grey
Whiskers Co
Visage Long
Forehead H Broad
Eyebrows Brown
Eyes Co N
Nose Medium
Mouth Small
Chin Long dimpled
Native Place
Remarks 1812 anchor flag mermaid E C
anchor E C Star on Right arm fish
anchor 1832 anchor anchor diamond on Rt. hand
anchor half moon 9 cots anchor I C E C fish an anchor
on left arm 1843 anchor on left hand scar
on Right Eyebrow on Rt. Breast

NAME, Collins Jane **No.**

Trade
Height (without shoes)
Age
Complexion Ruddy
Head Oval
Hair Dark
Whiskers
Visage Oval
Forehead M H
Eyebrows Dark
Eyes Co
Nose Long thin
Mouth Medium
Chin
Native Place
Remarks Man Smoking pipe S C Woman with Glass
Jane Bell Woman, man Smoking pipe R C Glass an

TATTOO SURVEILLANCE

Isaac Comer was not the first convict to have his tattoos described in the daily papers. When convicts absconded, their physical descriptions were circulated in the newspapers to aid in their recapture, and tattoos were deemed a particularly reliable means of identification. After his tattoos were published in the newspaper, bushranger Francis Fitzmaurice had the misfortune to be recognised by a couple of coppers on his way to the dock to skip Hobart Town. However, an analysis of absconding notices from the early 1860s suggests that tattooed convicts were not necessarily any easier to apprehend than those without tattoos. Absconders with tattoos were caught at roughly the same rate as those without. At this time, convicts released from prison also had their tattoos circulated in the press, so they could be recognised as ex-convicts.

Convicts were made painfully aware of the tattoo surveillance system when they were subjected to the humiliating and invasive processing on arrival in Australia. As a consequence, tattooing may have been less extensively practised in the penal colonies than it was on the voyage out. Accounts of convicts administering or receiving tattoos in Australia seem to be non-existent, and yet convicts were mustered and inspected on a weekly, sometimes daily, basis and freshly acquired tattoos would have been obvious. It is possible that the colonial authorities turned a blind eye to the practice not wanting to discourage further distinguishing marks that would aid identification.

Tattooing is not referred to in any of the rules and regulations governing the major sites of imprisonment in colonial New South Wales and Van Diemen's Land. By the 1860s there were more than 350 entries in the regulations for the penal station at Port Arthur, Australia's largest and longest-serving convict depot. Men were not permitted to talk during work or write even a few words without approval, but tattooing escapes mention.

While the authorities used tattoos to identify and to some extent control convicts, tattoos were used by convicts as a means to resist that control by asserting individuality and agency. Robert Dudlow was tattooed with the word 'cunt'. Like Comer's penis tattoo, this caused problems for the record books; the Van Diemonian clerk scribbled over the 't' and added 'indecent word'. Some such tattoos also disdained authority directly. Rule number 276 stated: 'Except when at labour clothing must be kept closely buttoned up.' Dudlow's expletive, however, had been cunningly pricked onto his right hand and was therefore beyond vesture censorship. And, according to rule 284, every time a convict passed a superior he had to raise his hand to his cap. So a mark of respect, from Dudlow, became an insult. However, obscene tattoos were rare—perhaps Dudlow's slipped by with little notice. Or it may have occurred to Dudlow's superiors to have him tattoo over his offending word.

Counter-tattooing as a form of censorship was not unheard of. George Williams, a convict from London, was tattooed with a naked man and a flowerpot on his right arm. At some stage the tableau was toned down with a 'pot and flower pricked over' the man. The prevalence of counter-tattooing among convicts is impossible to gauge, but it might have been a common practice. When Fitzmaurice was nabbed in Hobart Town some of his previously recorded tattoos had vanished and new tattoos had materialised. It is likely that Fitzmaurice had undergone a spot of remodelling, though his efforts failed to fool his captors.

Port Arthur *Regulations* circa 1840s, with the royal coat of arms of the United Kingdom, which also appeared tattooed on convicts. Fifteen-year-old George Empson bore the crest on his inner right arm.

REGULATIONS

FOR THE

PENAL SETTLEMENT

AT

Port Arthur.

DISAPPEARING INK

A tattooist, or 'pricker', typically began by tracing a design onto the skin. Gunpowder and charcoal were most commonly used as dyes but China-ink and Indian ink were also used. Less common were vermilion and indigo. A needle, or two or more needles bound tightly together, was repeatedly dipped in the ink, and, with the skin drawn tight, pricked over the outline to a depth that penetrated the outer layer of skin. Water, alcohol, saliva or urine was used to dilute the ink, clean the needle and wash off the blood.

Alfred Swaine Taylor, the 'father of British forensic medicine', was a nineteenth-century expert in medical jurisprudence. He noted that penetrative tattooing was permanent, but that tattoos applied lightly or with a soluble substance could fade and even disappear. Instances of fading tattoos pop up in the records. Van Diemonian convict William Vinnicombe was tattooed with the 'faint figure of a Crown & anchor', and Henry Sheldon with 'feint [sic] marks'. Crudely applied tattoos were probably quite common. Edward Crosby was tattooed with 'imperfect marks' and Joseph Johnson 'imperfect letters'. Professional or commercial tattooing did not take off until the late nineteenth century.

Accounts of convict tattooists are rare. At Yarmouth Gaol in Norfolk, England, convicted sailor William Jenkins practised his skills on a piece of bread, using a pin and a chunk of coal. By the time he arrived in Hobart Town he bore tattoos on both arms and hands. On his voyage to Van Diemen's Land, John Hill, another convicted sailor, worked day and night to keep his customers happy. Hill was not tattooed himself, but his tattooing earned him plenty of little luxuries such as tobacco.

In 1842, a British doctor noted that, due to unsanitary practices, tattooing could result in ulcers that took up to seven weeks to heal. But convict health records indicate ulcers and skin infections were not frequent. On board convict transports, tattooing was done extensively under squalid conditions to little apparent ill-effect.

The first comprehensive study of the possible health risks associated with the art was conducted in 1861, in France. It found that tattooing could cause numerous diseases leading to amputation and even death. Following the findings, tattooing was discouraged in the French armed forces. But in 1869, eight French sailors had limbs amputated and another eight died.

Attempting to remove or disguise tattoos was also hazardous. Methods included cutting, cauterising and counter-tattooing. One Frenchman attempting to avoid recognition was said to have doused his tattoos with various acids and, although the colour dissipated, the indentations left by the tattooist's needle remained and he was identified and convicted. Alfred Swaine Taylor believed that attempts to disguise tattoos could 'always be discovered'. When William Pocock arrived in Van Diemen's Land in 1850, it was noted that he bore 'marks of erased blue letters on rt. arm'. In 1835, Barnet Burns, an Englishman bearing the Maori markings 'Tā moko', was detained in Sydney under suspicion of being an escaped convict who 'underwent the operation to prevent his being recognised'. At this time, Australian towns were some of the most heavily policed in the world. Securing a new identity by altering one's tattoos may have been next to impossible.

Detail from *The British Medical Journal* 4 May, 1889. In 1888, an outbreak of syphilis at the Portsea Naval Barracks in England was attributed to a tattooist who 'mixed ink with spittle from his syphilitically ulcerated mouth'.

arms following
copper-coloured
me that they
n I found that
e enlarged, and
heir bodies. I
same person, a
was a hawker
nt to be S. I
d that he had
estioning these
his mouth or
it. I at once
nown that he
make it worth
ly disappeared
mmanding was
ning the men
ering all men
al inspection.
issioned officer
ne as himself,

up for inspec-
arm, together
ay by Surgeon
od plates.
isting of three
g, and which
essrs. Symonds

ith two well-
t falling off.
s colours with
the man, and
y duty, I was
rned out to be
for tattooing
was doing. I
that he had

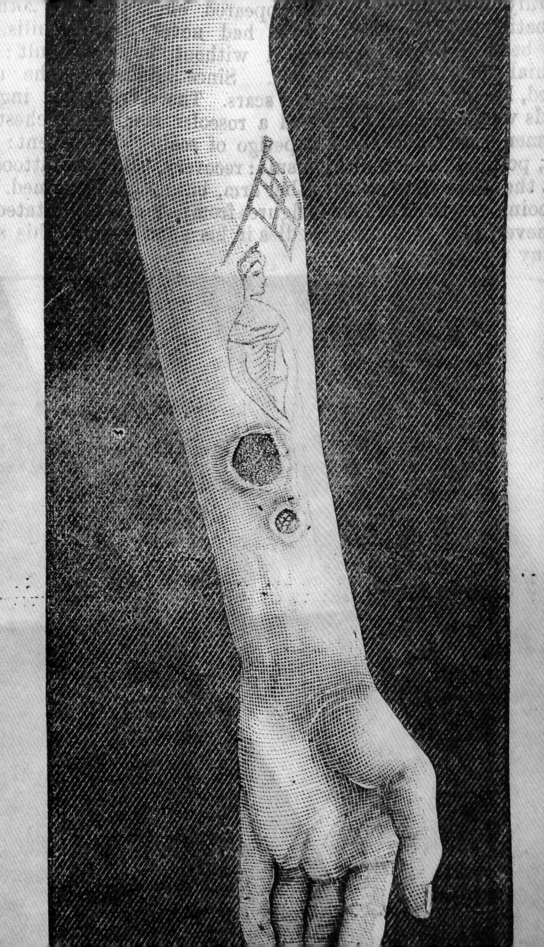

SEEING IS BELIEVING

'The presence of tattooed or coloured marks on the skin of a person, verified by a competent observer, may become the strongest proof of identity, and their proved absence, if not accounted for or explained, may furnish the most convincing evidence of non-identity. An escaped convict may allege that he never was tattooed. There may be no coloured marks on his skin, but a medical expert may be able to demonstrate that there have been such marks and traces of them still exist.' So claimed Alfred Swaine Taylor in 1874.

When John McDougall, who went by the name John Gow, arrived in Van Diemen's Land in April 1825, his real identity was all too apparent in the freshly pricked 'April 14th 1825 J McD' on his left arm. When George Huntly stood accused of piracy, his real identity was revealed as George Davis after a witness described a tattoo session that Davis underwent the morning he helped seize the ship. The evidence, the 'figure of a female', was considered irrefutable, and Davis was convicted and executed.

William Buckley's distinguishing tattoo was pivotal in saving his life. Buckley absconded in 1803 during a short-lived attempt by the British to establish a penal settlement in Victoria, and he spent the next thirty-two years living with the Watha Wurrung people. When he finally revealed himself to an astonished British expedition party, he was at first unable to recall his mother tongue and resorted to identifying himself by showing the initials tattooed on his arm.

The most infamous case of identity affirmed by a tattoo is the 'Tichborne Claimant'. In 1865, Thomas Castro, a butcher from Wagga Wagga in New South Wales, purported to be the missing baronet Sir Roger Tichborne, heir to the Tichborne fortune of Hampshire, England. The judicial proceedings that followed resulted in the longest trial in British history at that time. As it turned out, the claimant, as he was universally known, was neither Sir Roger Tichborne nor Thomas Castro but one Arthur Orton, whose wild scheme had finally unravelled when the initials R.C.T., and the symbols for faith, hope and charity—a heart, cross and an anchor—that had been tattooed on Tichborne's inner left arm failed to be found. During the trial, the tattooist was revealed as Lord Bellew. He confirmed that he and Tichborne had tattooed each other whilst boarding at the prestigious Stonyhurst College. Tattoos, it appears, were also popular among the upper classes.

At times tattooing was embraced by English monarchs. Legend has it that when King Harold was slain at the Battle of Hastings in 1066, his body was identified by his tattoos. King Edward VII was tattooed with a Jerusalem Cross when visiting the Holy Land in 1862. Twenty years later his sons, the Duke of Clarence and the Duke of York, were similarly tattooed. At that time, Londoners keen on acquiring a tattoo locally could visit Sutherland MacDonald in Jermyn Street. According to MacDonald most of his customers were from the armed forces but he also tattooed 'many noblemen' and 'several ladies'. MacDonald said that the chest and arms were the most popular parts of the body, and the price of a tattoo ranged from four shillings to twenty pounds. For certain clients, tattooing, often a painful procedure, was rendered painless with an additional injection of cocaine.

Detail of William Todd's journal from 1835. In his account of meeting Buckley, Todd sketched the escaped convict's tattoos, which included his initials, the sun, the moon and a bird.

livth the Natives.

...covered his

...was 6 feet 7 to 8 inches
half.

...s his name was

...ing the following

...term — W·B· ☼ ☾ 🦜

...me with the Natives

...forgot the English

the Native Language
674/0

...fluently.

...him to our

THE CRIMINAL CODE

During the latter half of the nineteenth century, tattooing caught the eye of criminologists, most notably, an Italian named Cesare Lombroso and Frenchman Alexandre Lacassagne. Both men were influenced by the pseudo-science of phrenology, the idea that human skull configurations were indicative of character and intelligence. Lombroso and Lacassagne deemed tattoos an expression of atavism—a tendency to revert to a primitive, uncivilised nature—and therefore evidence of criminal leanings. They also asserted that tattoos formed a uniquely criminal language—an argot. Isaac Comer, who had been booted out of the 73rd Regiment for boozing and sentenced to transportation to Van Diemen's Land for thieving, exhibited certain 'atavistic' traits—Lombroso had concluded that soldiers and convicts were more likely to be tattooed on their private parts—but, according to Comer's physical description, he lacked the low forehead, large jaw and long arms of, according to Lombroso, the 'born criminal'.

Despite a growing belief that tattoos were a defining criminal trait, a late-nineteenth-century survey of men and women who arrived at Derby Prison in England over a three-month period found that just seven per cent were tattooed: 'chiefly soldiers, with a few miners and sailors'. The extent of tattooing undertaken within the prison was not recorded. Similarly for convicts in Australia, records detailing tattoos were not made before they shipped out, and the post-arrival physical descriptions generally weren't updated unless the convict moved colonies, absconded or reoffended following release. So the full extent of convict tattooing can't be known. However, it is known that at least thirty-seven per cent of men and fifteen per cent of women arrived in Australia bearing tattoos. But convict tattooing was not a consequence of biological or social inadequacy; rather, it was a response to dehumanisation. British and American seamen, who experienced a similarly regimented life labouring under harsh conditions far from family, bore the very same motifs. Convicts, who endured a more inhumane regime, had the higher frequency of tattooing.

The physical descriptions of convicts who shipped together show that there were factions tattooed with distinct designs reflecting a shared experience of transportation, not a criminal affiliation. Eighteen men aboard the *Moffatt* were tattooed with a willow tree. Sixteen men aboard the *Lotus* were tattooed with the bust of a woman, and thirteen men of the *Layton* with a woman clutching a flower.

Shipboard tattooing was commonplace, if not customary. After voyaging to Tahiti with Captain James Cook in 1773, midshipman John Elliott recalled 'our Mess conceived the idea of having some mark put on ourselves, as connecting us together, as well as to commemorate our having been at Otaheite [Tahiti]'. Elliott and his messmates each had a star tattooed on the left side of his chest, sparking one of the earliest documented tattoo trends among Englishmen. In Tahiti fifteen years later, *Bounty* crewmen acquired the same tattoo, and in the fifty years following, several convicted sailors arriving in Australia had been similarly tattooed.

The kind of code suggested by late nineteenth-century criminologists is not obvious in convict records. Tattoos like the Tahitian star, or more typical unifying motifs such as a love heart or finger ring, cannot be exclusively attributed to criminals. Christians and Masonic convicts might have been the only contingents

Cesare Lombroso's depiction of a rapist and the '105 signs relating to his crimes'.

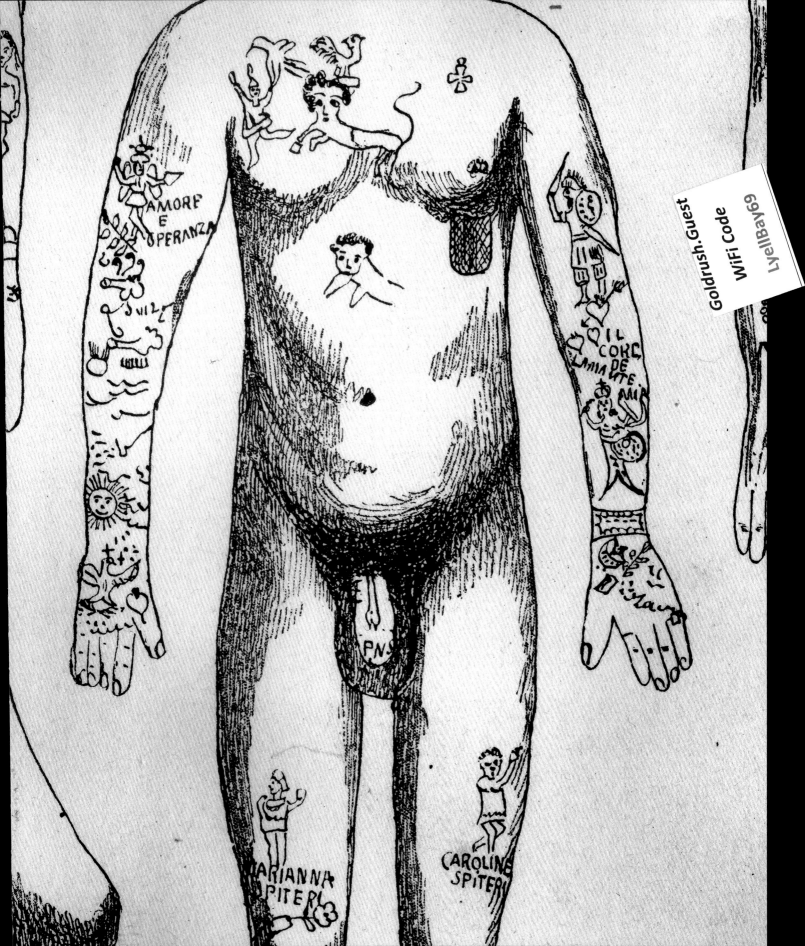

to have explicitly embraced a tattoo argot, but neither group was criminally motivated in their choice of design. If tattoos were being used as a form of secret, sinister communication, the authorities who meticulously examined and recorded tattoos would have probably caught on. When a lad named John Starkey was spotted suspiciously lurking about London's Lyceum Theatre, the love token in his pocket—inscribed with his name and pictures of pistols, skeleton keys, a crowbar, lock-pick, lantern and matchbox—was so damning that he was gaoled for two months.

The authorities were, in fact, well aware that tattooing could be a means of nefarious expression, as they used a similar system themselves. Some criminals were branded with letters to mark their crimes, such as 'F' for felon, 'M' for murder and 'T' for theft. By the beginning of the nineteenth century, branding had been largely abolished but army deserters continued to be tattooed with the letter 'D'. Some Brits remained in favour of branding criminals: 'if you cannot deprive the serpent of his venom, you should not free him from his rattle' was the opinion of one gaol governor. Samuel Downes, a boy accused of stealing, claimed that inmates at Chester Castle in the northwest of England were being branded. But the so-called 'convict mark', a ring tattooed between the thumb and wrist, is not recorded on Australian convicts hailing from Chester. Some, however, had five dots tattooed between their thumb and forefinger, an insignia attributed to a criminal faction dubbed 'the Forty Thieves'. But the mark became commonplace, making it difficult to identify gang members from their records.

In the first half of the nineteenth century, gang activity in England was rife. A number of gangs went by territorial names, such as the High Street Gang, the Whitechapel Gang, the Henry Street Gang and the Laurel Street Gang. The Aldington Gang comprised smugglers from the villages of Aldington and Billingston. Gangs that operated out of Staffordshire, a county renowned for its pottery, were known as 'pottery gangs'. But, contrary to the idea of tattoos as marks of affiliation, gang members are not recorded as having any particular tattoos in common. The most notorious gang was the Swell Mob, which emerged during the 1830s. Charles Dickens described its members as 'respectable looking men; of perfectly good deportment and unusual intelligence'. Members of the Swell Mob were infamous for feigning respectability in order to mingle with the elite and perpetrate lucrative crimes. Tattoos might have undermined their objective—out of thirteen Swell Mob members transported, eleven arrived without tattoos. At this time, gang members might have been less inclined to bear tattoos that could potentially link them; an Act of Parliament decreed persons connected with the robbing of an individual, who accompanied that robbery with violence, should either be transported for life or for fifteen years, or imprisoned for three years, at the discretion of the judge.

Other convict groups do not appear to have turned to tattooing to communicate an argot either. Chartists, who took their name from the People's Charter of 1838, were working-class Brits who campaigned for equal voting rights for men, regardless of class or property ownership. In 1839, leading campaigners John Frost, William Jones and Zephaniah Williams were arrested and charged with high treason. The trio became the last men sentenced to be hanged, drawn and quartered in England. Following public outcry, their sentences were commuted to transportation for life and they sailed to Van Diemen's Land aboard the *Mandarin*. Despite their distinct bond, they stepped ashore free from tattoos, as did the other chartists aboard.

Ribbonmen comprised a secret society of Irish Catholics. Ribbonists, as they were also termed, opposed

Dandy Pickpockets Diving, 1818, by Isaac Robert Cruikshank. Two well-dressed men conspire to pick the pocket of a man in St James Place, London.

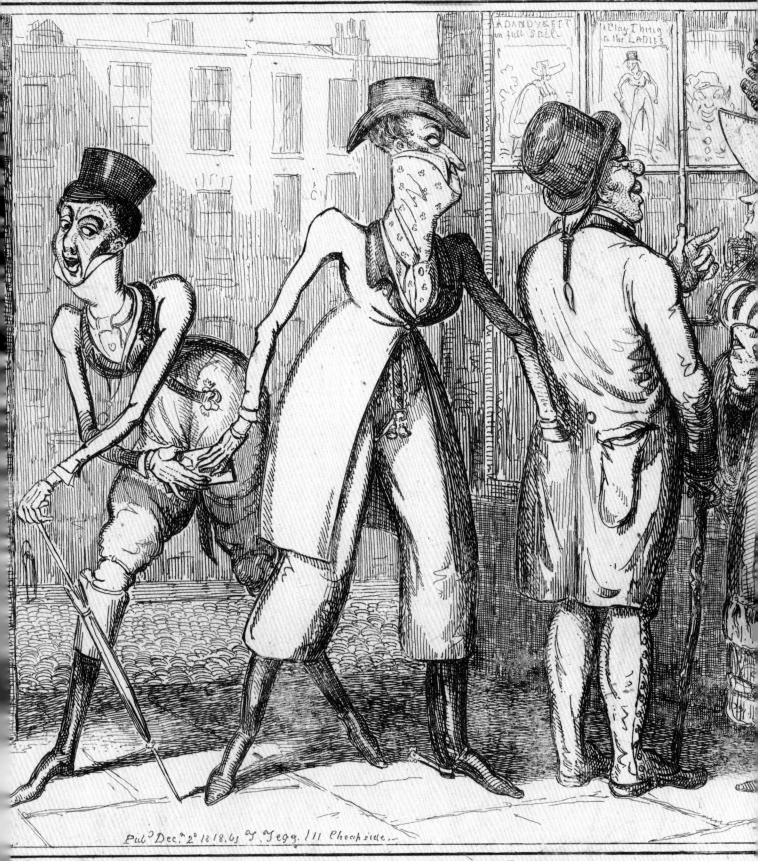

Pub.^d Dec.^r 2.^d 1818. by T. Tegg. 111 Cheapside.

DANDY PICKPOCKETS, diving.

Protestant oppression and defended the rights of tenant farmers and rural workers. Ribbonmen took their name from the ribbons they wore to mark their solidarity. They do not appear to have used tattoos for the same purpose.

Impoverished agricultural workers who protested against mechanisation in England were known as Swing Rioters and also 'machine breakers'. They committed crimes such as arson, machine breaking and rioting, and some 480 of them were transported to Australia. The tattoos of the 224 Swing Rioters who sailed on the *Eliza* in 1830 do not indicate anything of a particularly lawless or connective nature.

Gangs that formed in Australia do not appear to have used tattoos as an argot either. According to a reward poster from 1826, four of the twelve men in Matthew Brady's bushranging gang bore tattoos, but the motifs were commonplace. Following their arrests, portraits of the gang were made before and after execution for phrenological study. Any shared tattoo designs would have been noticed under such intense examination.

In the early 1840s, an inquiry into female prison discipline alleged a group dubbed the Flash Mob was running a smuggling racket and engaging in lesbian relationships. The local press reported that through 'process of initiation' the 'wretches' were 'admitted into a series of unhallowed mysteries' akin to 'Faust'. But if their tattoos were indicative of such 'vice, immorality, and iniquity', they failed to gain a mention. The Brady Gang was, however, well known for wearing top hats and fancy coats and the Flash Mob for donning silk scarves and jewellery. But the most flamboyant of all was the Jewboy Gang, whose members commenced their bushranging career after escaping Sydney's Hyde Park Barracks in August 1840. The gang, it seems, were inclined to be more than a little fabulous. As reported by the *Sydney Morning Herald*, 'They wore broad-rimmed Manila hats turned up in front with abundance of broad pink ribbons, satin neck-cloths, splendid brooches, all of them had rings and watches...the bridles of their horses were also decorated with a profusion of pink ribbons.' If they had acquired any tattoos after escaping, the press, it seems, did not get wind of it. By adopting an aristocratic air, these convicts subverted the social stratification. Tattooing for them may have been contrary to their purpose.

Some convicts bore tattoos indicative of infamy: trial dates, prison terms and images such as James Spencer's 'boy picking a man's pocket'. But the vast majority of recorded convict tattoos express humanity, not criminality.

Tattooing helped convicts cope with the traumatic ordeal of transportation, rebel against the uniformed rank and file of penal life, and reassert their sense of identity and individuality. Isaac Comer's tattoo collection set him apart from both civilians and convicts. His appearance in the *Mercury* did not go unnoticed and other newspapers ran with the story. When it reached Queensland, the editor chose to comment: 'Tattooing in its extensive form is generally believed to be an appanage of uncivilised life, but an example is afforded to the contrary by the Hobart Town *Mercury*, which goes to show that white men sometimes indulge to a high degree in this decoration of the body.'

A Cadger's Map of a Begging District in Kent, 1849. Tramps, or 'cadgers', were said to have communicated via secret signs etched into fences, gateposts and door-ways, which may have contributed to the belief in an argot circulating the criminal underworld.

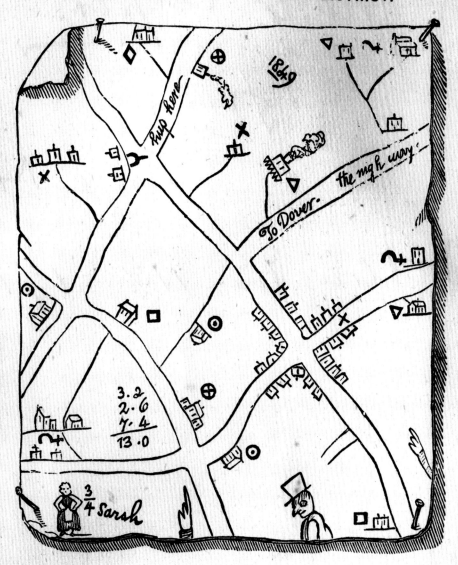

EXPLANATION OF THE HIEROGLYPHICS.

No good; too poor, and know too much.

Stop,—if you have what they want, they will buy. They are pretty "*fly*" (knowing).

Go in this direction, it is better than the other road. Nothing that way.

Bone (good). Safe for a "cold tatur," if for nothing else. "*Cheese your patter*" (don't talk much) here.

Cooper'd (spoilt) by too many tramps calling there.

Gammy (unfavourable), likely to have you taken up. Mind the dog.

Flummuxed (dangerous), sure of a month in "*quod*," prison.

Religious, but tidy on the whole.

See p. 31

TATTOO ORIGINS

In July 1769, Captain James Cook of the *Endeavour* recorded the word 'tattow' after observing Tahitians indelibly marking their skin with a black substance procured from charred nuts. When the *Endeavour* returned to England two years later, Cook and company stepped ashore touting exotic specimens and souvenirs, including some pricked into their skin. The ship's botanist, Sydney Parkinson, had both his arms tattooed. He described the designs as a 'lively bluish purple, similar to that made upon the skin by gunpowder', which could suggest that tattooing was already practised in England. When the *Bounty* reached Tahiti, on 25 October 1788, seaman Thomas Ellison chose not to memorialise the moment with a Tahitian design but with his name and the date. The tattoo proved to be a prophetic epitaph— Ellison was hanged for participating in the infamous *Bounty* mutiny four years later almost to the day.

English seamen have been credited with introducing the 'tattow' into Britain, but, in fact, they only helped to popularise an existing custom. Tattooing had been practised in Europe centuries earlier, before the Christian era. There are also examples, including Ellison's tattoo, of late eighteenth-century tattooing that are not Polynesian in nature, suggesting that English-style tattooing was already an established tradition by this time. Records detailing American seamen taken between 1796 and 1818 describe tattoos of characteristically English design, such as names, initials, anchors and hearts. When convict tattoos began to be catalogued in Australia, those very same designs were recorded—it seems that tattooing was such an established artform that the designs had become standardised across the globe.

It is likely that eighteenth-century tattoo culture was influenced by popular print: broadsides—sheets of inexpensive paper printed on one side—contained songs, poetry, folk tales and current events, frequently with illustrations. Broadsides were cut into strips to produce multiple prints, called slip songs, and folded into booklets called chapbooks. By the mid 1700s transfer printing had developed into a fast and cost-effective method of impressing images onto ceramics, glassware and enamelware, making decorated crockery and trinkets relatively affordable. Many of the images that would end up described in convict registers were printed on everyday items and keepsakes, such as mugs and snuff boxes.

Approximately half of all convicts were illiterate— Isaac Comer, according to his record, could read, but not write—so symbols may have held particular appeal as tattoo images. Some tattoo motifs had already endured for centuries. The Greco–Roman anchor, fish and mermaid became Christian symbols to express hope, faith and vanity.

In colonial Australia, hundreds of thousands of tattoos were recorded, perhaps a greater number than anywhere else in the world, yet little or no contemporaneous analysis was made, and very few images were reproduced for posterity. When ex-convict William Beulow Gould painted a self-portrait in 1838, he covered his 'several blue marks stars etc' with his sleeves. And none of the photographic portraits of Van Diemonian convicts taken during the late nineteenth century shows their tattoos.

A broadside: '*AN HIEROGLYPHIC* Epistle from a [sailor] on Board a [ship] [toe] his Sweet [heart]', printed in 1799. 'Hieroglyphic' letters were also known as phonograms and pictograms. The same symbols are described in convict tattoo records.

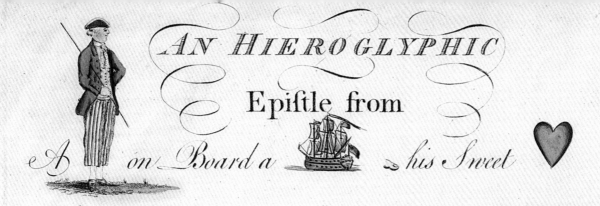

AN HIEROGLYPHIC
Epiſtle from

A [sailor] on Board a [ship] [to] his Sweet [heart]

D[ear] Sally

 Tho' toſs'd [b]y the [wind] on the Ma[i]n

[I] [sailor] I ſh[all] See thy D[ear] [face] once aga[i]n

[You] muſt know my [dear] [life] no Sooner ſet [sail]

[We] were at[tacke]d [b]y a Teri[ble] gale

Old [Nep]tuſti [himself] [hog]as Came on fore & aft

T[ill] the [ship] ſcarce a[ppear]'d an[eye] more t[han] a raft

Our [ballon][sail]s [were] lower'd w[i]thout e'er A [bow] low

And our [men] [i]n conf[usion] we could [not] tell how

A [leak] ſprung [be]low we were [P]reſently told

And [4] Fathom Water w[as] found [i]n the hold

[death] [stare]d [us] [in] the [face] w[hile] the cry t[hat] was h[ear]d

And [I] [i]n each v[i]sage [di]ſmay'd Horrid ap[pea]r'd

W[e] after the [priest] and we went to [P]rayers

The [wind] [blew] a[bout] and Diſ[pe]ld [all] our f[ear]s

N[ear] the Coast of Good [Hope] we arr[i]v'd Safe [i]n Port

[all] danger q[u]ite over we [make] it [all] Sport

We [box]'d round the [can] and we Jov[i]a[ll]y Sing

God [B]leſs [all] our ſweet [heart]s and Long l[i]ve the K[i]ng

So [I] [life] t[hat] [jug] [heart] will [be] ho[nest] and true

And [B]e[lie]ve me S[i]nc[e]ly [I]'m [yours]

 Tr[u]ly Le

TATTOO TAXONOMY

Pictorial records of Australian convicts' tattoos are rare, but examples of nineteenth-century tattoos have survived. Alexandre Lacassagne traced over his subjects' tattoos, accumulating some 1600 designs. Other analysts took this a step further and removed tattooed flesh from cadavers. In 1929, Henry Wellcome, an antiquarian and pharmaceutical entrepreneur, purchased more than 300 pieces of tattooed skin from a mysterious Parisian doctor, who had filched the skin from the bodies of 'sailors, soldiers, murderers and criminals of all nationalities'. The collection is held by the Wellcome Museum in London and is considered the most significant of its kind. Lacassagne classified his tattoo collection into seven categories: occupational, military, patriotic, religious, inscriptions, love/eroticism and metaphoric/historic emblems. Cesare Lombroso used just four: love, religion, war and occupation.

Convicts' personal histories, their tattoo records in the Black Books and the symbolism popular at the time, when looked at together, can reveal stories behind the tattoos. An anchor is a well known symbol of hope, a crucifix symbolises salvation, and a group of seven stars can represent the Pleiades constellation. The anchor, crucifix, initials J.B., I.C. and seven stars on the back of Isaac Comer's right hand could be read as 'Through salvation Jane Bell and Isaac Comer hope to be together'. But depending on when and where the tattoos were acquired that story could be subtly different—did Isaac Comer hope to remain with Jane Bell or be reunited with her? Did the tattoos pertain to his absence whilst serving in the 73rd Regiment or his sentence of fourteen years' transportation? Did he hope union would take place under the Pleiades constellation in his hometown of Bath or in heaven? The I.C. J.B., upside-down crown and anchor on his left arm could signify that hope of reunion by way of a royal pardon was lost.

While the situation in which a tattoo was obtained gave it its original meaning, a tattoo's permanency carries it through time, and it can appear to take on a new meaning in new circumstances. When Isaac Comer was sentenced to life imprisonment and transported to Norfolk Island in 1846, his Jane Bell tattoos took on a more tragic meaning. When he was being bounced from one invalid depot to another in his twilight years, their significance changed yet again. And when Comer was finally dead and in the ground, his tattoo likeness of Jane Bell was laid to rest with him.

Convict tattoos were cursorily recorded without explanation from the bearer or pictorial illustration. They were listed but not interpreted. Descriptions of them can be read but they cannot be seen. They are metaphysical anomalies: liberating as a means of expression but incriminating as a means of identification; publicly seen but only privately understood; of great personal value but of little monetary worth; tangible in the flesh but intangible without it. Tattoos inhabited a unique space on the skin and in the hearts and minds of the men, women and children transported to Australia.

An illustration of convict absconder Miles Confrey from an 1854 issue of Punch Almanack. Punch presented Confrey as an unmistakably recognisable fugitive on account of his tattoos. Confrey, however, disappeared without trace and avoided a sentence of ten years' hard labour in Van Diemen's Land. The Confrey cartoon provides one of the few illustrations of a tattooed convict.

for on reference to the punctuation we find the patches to have been composed of these materials. We should imagine that unless his career had been ere this cut short, the 5th of November can hardly have passed without his having been called on to play a conspicuous part.

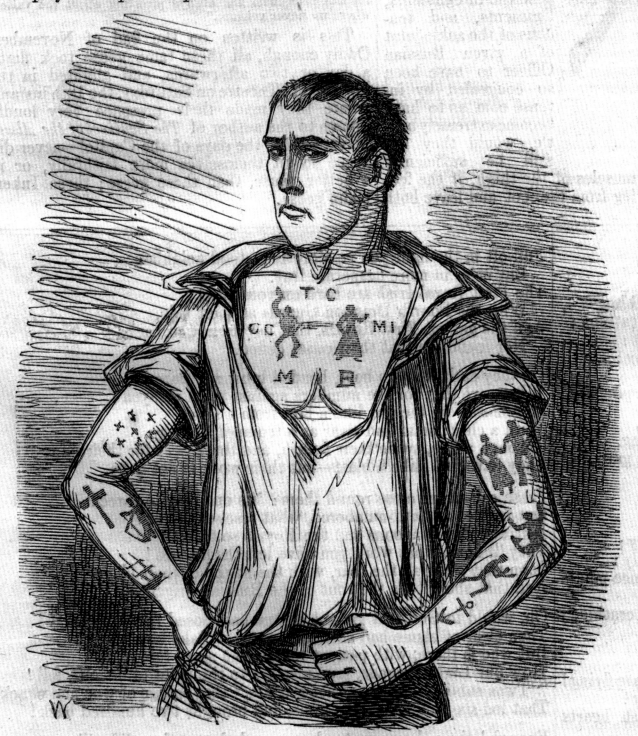

"Escaped, from the *Defence* Hulk, at Woolwich, on the 20th instant, MILES CONFREY, twenty-three years of age, five feet six inches high, light brown hair, grey eyes, fresh complexion, and slight made; a man in fighting attitude, man, woman, mermaid, and anchor on left arm; half moon, seven stars, crucifix, ship, and hope on right arm; man and woman, T.C. and C.C., M.L. M.B. on breast. By trade a tailor, and a native of Manchester."—*Bow Street, October* 21.

The difficulty of recapturing MILES CONFREY would, we think, certainly be increased by that gentleman's peculiar eligibility for the part of an Indian chief

THE FINER POINTS

When convicts were processed on arrival, their tattoos were called out by an official and recorded in the Black Books by a clerk. The inspection usually began with the upper right arm, followed by the right forearm and right hand and then the upper left arm, left forearm and left hand. Tattoos on the face, chest, stomach, legs and genitals were noted in no particular order. In most cases the tattoos were recorded as a continuous list, without distinguishing motifs that may have formed composite images from those that were single image tattoos. In some instances, clerks used a conjunction, such as William Thompson's 'Anchor & Cable', the fouled anchor motif. Images that appear more than once in a convict's physical description may have had different meanings in each instance: Thompson's 'Anchor, Woman' probably depicted the virtue of hope, while his 'Cutter Anchor Mermd' may have had a meaning as one, or they may have been three separate tattoos of unrelated significance.

Women were less likely than men to have multiple tattoos and probably less likely to have large images, as they were rarely tattooed on the chest. Women were more likely than men to be tattooed in less visible areas, such as the shoulder or leg, but, like men, most were tattooed on their forearms.

Because the authorities recorded tattoos as a means of identification, some tattoos may have been deemed immaterial and not recorded in favour of other attributes. The physical descriptions of black convicts are frequently limited to 'black' or 'man of colour'. Jewish convicts were often described only as 'Jew' or 'Jewess'. There were, however, exceptions—John William Jones, born in Barbados, was recorded as having tattoos, and Samuel Cohen recorded as 'A Jew', had the tattoo on his right arm listed.

Some descriptions in the Black Books appear to refer to tattoos but, in fact, describe medical conditions.

Charles Talbot was listed as bearing the 'King's Evil' under each side of his jaw. The King's Evil was slang for scrofula, tuberculosis of the lymphatic glands, which commonly scarred the neck. Convicts with eye defects were said to have a 'feather' in or near the eye. John Pratt was described as being 'Nearly blind left Eye. Feather in each Eye'. Other descriptions presumably referred to birthmarks and tumours. Bridget Cassidy had the 'mark of tobacco leaf' on her right thigh; Sydney Harris the 'natural Mark of a Suckling pig on chest'; Ann Caldwell a 'strawberry mark' on her neck; and Joseph Reece a 'Wine mark' on his right cheek.

It appears from the frequency of tattoo motifs, that initials or names were popular first tattoos. Women often chose dots or a heart for their second tattoo, and men an anchor or a woman. Most tattooed convicts had more than one tattoo.

Tattoos appealed to convicts of all ages and backgrounds. One of the youngest was ten-year-old Hugh Smith, among the oldest was 76-year-old James Watt. The most extensively tattooed convicts were Englishmen who had served in the army and navy.

Tattooed convicts do not appear to have been more disobedient than those without tattoos: convicts who were transported more than once were tattooed at roughly the same rate as other convicts, as were those who'd been condemned to death but had their sentences commuted to transportation. Convicts who were sentenced to die on the Van Diemonian gallows had a slightly higher rate of tattooing on arrival, but as convicts did not have their tattoos recorded again prior to their execution, the extent of their tattoos cannot be known.

Isaac Comer, aged thirty-one, undergoing inspection in Hobart Town, 1845.

HEAD

Tattoos on the head were rare. Hohepa Te Unmroa, a Maori transported from New Zealand, bore incomplete tā moko on the left side of his face. Fourteen-year-old James Young had initials and an upside-down anchor on his chin. Richard Farmer had 'blue marks on face', which were attributed to an 'explosion from a mine'.

CHEST

The chest provided a canvas for larger tattoos. The area around the heart was sometimes reserved for tattoos displaying affection. In red ink on the chest of Jacob Gleed were initials and people, probably his wife and children. Thomas Mead emblazoned his chest with the word 'free'. Army deserters were branded with a 'D' on their left side or their left breast. Chest tattoos were rare among women. Those that did have them tended to have dots. Maria Dover bore five on her 'left breast' and Anne Connolly had 'one on chest'.

ABDOMEN

Few convicts were tattooed on the belly. The chest may have taken precedence due to aesthetics and the difficulties of tattooing malleable flesh.

ARMS

Arms were most commonly tattooed. Convicts were more inclined to bear tattoos on their forearms than anywhere else, and almost twice as likely to be tattooed on the left arm than the right, which suggests that many tattoos were self-administered. Tattoos on the inner arm were less visible and some were of a more private nature.

GROIN

Few convicts had a tattoo on the penis, which was politely termed 'yard' or 'between the legs' in the records.

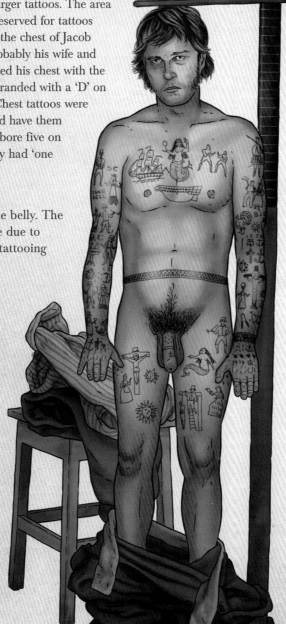

SHOULDERS

Women were more likely to be tattooed on the shoulders than men. On Elizabeth Smith's right shoulder was a man, the letters 'I L Heart' and a wreath.

BACK

Back tattoos are noticeably absent from convict tattoo descriptions. When William Mellors absconded from a London prison hulk in November 1838, the *Kentish Gazette* listed some of his many tattoos: 'a stag on breast-bone, a man with his hand in his pocket and a glass in his hand, a dog underneath, a woman with parasol and reticule, a gate on lower part of back, a dog on left side'. When Mellors arrived in Van Diemen's Land nine months later, those tattoos were not recorded. Some tattoos, particularly larger collections in less visible areas such as the back, were not recorded.

HANDS

Rings were tattooed around fingers and bracelets around wrists. James Spicer was tattooed with a flower around each wrist. As one of the most visible parts of the body, hands are the prime position for symbols of allegiance, such as the five dots attributed to a gang known as the Forty Thieves.

LEGS

Leg tattoos were rare, but more common among women than men. Elizabeth Holding was tattooed on her right thigh and Lucy Williams on her right knee. Whilst in Burma, ex-soldier Henry Findlay was tattooed on his calves and from his knees to his groin. Thomas Kinsman was tattooed with the date of his trial on the left side of one foot.

23

Exactly when English authorities began systematically recording the tattoos of criminals is not known. The tattoos of the *Bounty* mutineers were circulated in 1789, and the tattoos of less sensational criminals appeared with greater regularity in British papers soon after. In Australia, tattoo descriptions began to appear regularly in newspapers in the 1820s. At the main police station of Liverpool, known as the 'Main Bridewell', a 'Mark Book' was kept in which tattoos were recorded and replicated as 'pen-and-ink sketches'. In 1857, the ledger caught the eye of a reporter who seized the opportunity to write an expose, feeling that 'antiquarians have bestowed no attentions as yet on this heraldry of the sea'. The article appeared in an edition of the *Liverpool Mercury*, and listed the following motifs: 'triangles, globes, suns, stars, hearts, anchors, diamonds, flags (of all countries), crosses, initials, mottoes, arrows, tombs, ships, tents, death's heads, trees, flowerpots, mermaids large and small, and animals and devices of every kind'. Crucifixes and figures of Adam and Eve were particularly popular and many men had their 'sweethearts' names inscribed', which the newsman commented on as 'touching'. However, he also noted that 'indelicate' depictions of 'nude females abound'. The reporter then posed a question commenting on the prevailing attitudes to tattoo culture: 'Are seamen really a very criminal class, or is the system of tattooing common among thieves or the lower class on land?' As approximately half the inmates in the Main Bridewell were drunks, and not hardened criminals, he concluded 'the latter hypothesis' was most likely.

The work of the Liverpudlian tattooists was described as 'remarkably well executed', 'ornate in character' and 'beautifully coloured'. The colonial authorities paid no attention to style or skill but lettering and colouring was occasionally noted. John Poulin was tattooed with a rose and thistle in 'red and blue ink' and William Hazel with initials in 'Old English'. The most common description of the appearance of tattoos pertained to fading, as with Joshua Artis' 'several faint blue marks'.

After convict George Isherwood returned to England a free man, his body was recovered from a canal with 'several wounds to his throat'. At the inquest into Isherwood's death the coroner described his tattoos as a 'well-executed representation of the crucifix' and 'beautifully tattooed in capital letters' was the hymn:

SEE FROM HIS HEAD HIS HANDS HIS FEET
SORROW AND LOVE FLOW MINGLED DOWN
DID ERE SUCH LOVE & SORROW MEET
OR THORNS COMPOSE SO RICH A CROWN

Isherwood's Van Diemonian record gives no indication of the artistry of the tattooist but it does reveal that he was also tattooed with a woman, an anchor and his initials. It is possible that these tattoos had faded in the twenty-seven years following their listing in the record. A nineteenth-century investigation into tattoo durability concluded that tattoos could fade completely after twenty-eight years. Instances where tattoos were recorded a second time, later in life, indicate most convicts didn't add to their tattoos, and in some instances their tattoos, like Isherwood's, disappeared. Henry Page's tattoos were recorded in 1824 when he was twenty-one, in 1873 at seventy-one, and in 1880 at seventy-eight. It seems that his tattoos changed erratically. Stranger still is the thumb and forefinger reported to be missing from his left hand in 1824 that by 1880 were missing from his right hand. In all likelihood, the authorities were simply less concerned with accurately cataloguing ageing convicts as they slowly faded into obscurity.

A graphic representation of the prevalence of tattoo images among 6806 men transported to Van Diemen's Land between 1823 and 1853. The centre graph shows the percentages of men bearing tattoos, with each year calculated from one representative ship. The rings show the frequency of their tattoo motifs.

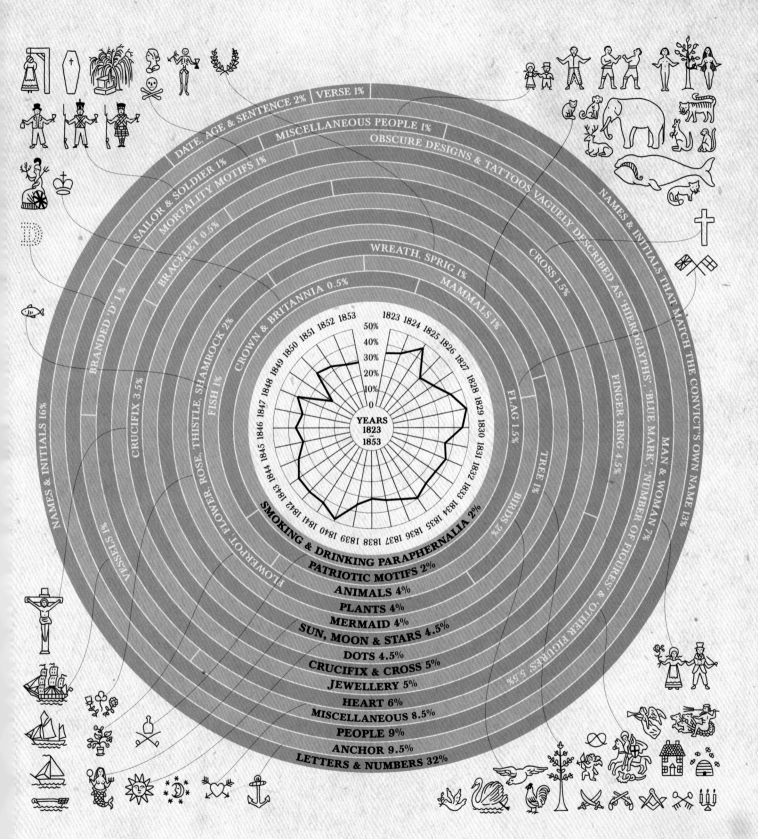

VERSE 1%

DATE, AGE & SENTENCE 2%

MISCELLANEOUS PEOPLE 1%

OBSCURE DESIGNS & TATTOOS VAGUELY DESCRIBED AS 'HIEROGLYPHS'

SAILOR & SOLDIER 1%

MORTALITY MOTIFS 1%

BRACELET 0.5%

WREATH, SPRIG 1%

MAMMALS 1%

CROSS 1.5%

BRANDED 'D' 1%

CROWN & BRITANNIA 0.5%

NAMES & INITIALS THAT MATCH THE CONVICT'S OWN NAME 13%

CRUCIFIX 3.5%

FISH 1%

FLOWERPOT, FLOWER, ROSE, THISTLE, SHAMROCK 2%

FLAG 1.5%

FINGER RING 4.5%

NAMES & INITIALS 16%

VESSELS 1%

SMOKING & DRINKING PARAPHERNALIA 2%

PATRIOTIC MOTIFS 2%

ANIMALS 4%

PLANTS 4%

MERMAID 4%

SUN, MOON & STARS 4.5%

DOTS 4.5%

CRUCIFIX & CROSS 5%

JEWELLERY 5%

HEART 6%

MISCELLANEOUS 8.5%

PEOPLE 9%

ANCHOR 9.5%

LETTERS & NUMBERS 32%

TREE 1%

BIRDS 2%

MAN & WOMAN 7%

'BLUE MARK', 'NUMBER OF FIGURES' & OTHER FIGURES 5.5%

YEARS
1823
–
1853

50%
40%
30%
20%
10%
0

1823 1824 1825 1826 1827 1828 1829 1830 1831 1832 1833 1834 1835 1836 1837 1838 1839 1840 1841 1842 1843 1844 1845 1846 1847 1848 1849 1850 1851 1852 1853

25

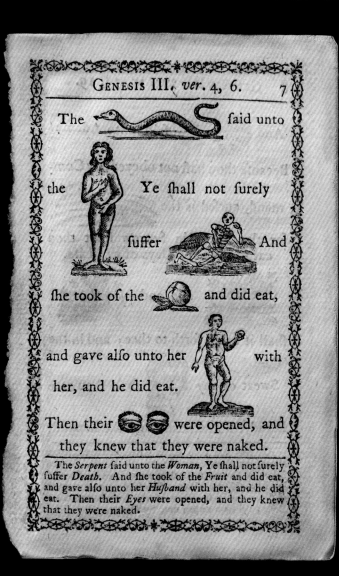

Adam and Eve from *A Curious Hieroglyphick Bible*, 1792. In the eighteenth century, illiteracy was widespread, as schooling was limited to the upper classes. Sunday Schools were set up to educate working-class children. Scripture was conveyed to the illiterate using symbols, often similar to those used in tattooing. 'Hieroglyphick Bibles' were among the most heavily illustrated of the few books available at the time and probably an inspiration for budding tattooists.

Images of people account for nine per cent of male convict tattoos. In most cases, such as James Parlour's 'Woman holding a Basket' and Joseph Dale's less typical 'woman without a head', their identities and particular significance are unknown. In a culture instilled with Christian values, Adam and Eve were iconic and frequently described in detail in the records. The image of Adam and Eve with a serpent-entwined tree has symbolised the 'Fall of Man' for centuries. Despite their recognisability, depictions of the Biblical couple can be difficult to distinguish in the records from tattoos of other men and women; in some instances they could have represented either.

For transported convicts, the Adam and Eve motif was particularly pertinent, as a transportation sentence frequently resulted in permanent exile. John Mitchel, an Irish Nationalist, described Van Diemen's Land as the 'gardens of Hell', and his sentence as an 'infernal pilgrimage' that was to be endured in 'grim solitude' for he would not subject his family to 'that island of the unblessed'. In his memoirs, convict Linus Miller referred to Van Diemen's Land as 'The land of Nod', which, according to the Book of Genesis was a place of banishment east of the Garden of Eden. William Bray expressed this sense of eviction in his tattoo. Pricked on his right arm were Adam and Eve whom he had monogrammed with W.B. and M.B., his initials and those, most likely, of his wife. Fourteen-year-old Joseph Dummet was also tattooed with the Adam and Eve motif along with the heartfelt admission: 'the serpent beguiled me & I did Eat'. Fifty-year-old William Shemett was cloaked in pious sentiment. Across his chest was Christ crucified, with a Roman Centurion and Mary Magdalen. Nearby was Jesus riding an ass to Jerusalem and the words 'O god have mercy on me a Sinner' along with a man and woman, possibly Adam and Eve. The

people Marion Telford had tattooed on her limbs are easily identified as they were transcribed as 'adam and eve on left arm' and 'man and woman dancing on right arm'. However, George Scott's 'man and woman' almost certainly depict Adam and Eve, as they appear with a 'tree serpent'. James Brimelow was tattooed with a 'man woman & 2 Childn' on the inside of his right arm: most likely himself, his wife and the two children noted in his record. The family portrait was balanced by a tattoo of Adam and Eve and two trees—probably the blooming Tree of Life and the withering Tree of Knowledge of Good and Evil—on the inside of his left arm.

Trees were popular tattoo subjects, but they, too, were not always clearly recorded. In the odd instance, such as Thomas Sander's 'fig tree serpent and eve', the type of tree was identified. By having Eve without Adam, Sander may have been emphasising temptation. William Moulton had only the tree and serpent. James Carter had just a tree, and, as fate would have it, he was transported to Van Diemen's Land aboard the *Eden*. William Brown, however, did not exclude a component so much as replace it: Brown bore a tree next to two naked men.

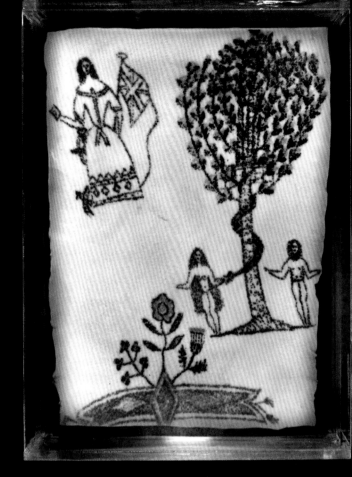

Tattooed human skin, circa 1800–50. A woman, reminiscent of Britannia and the virtue of hope, stands in front of a 'fouled anchor' and the British ensign. In her hand is a letter. Adam and Eve stand beside the Tree of Life as the serpent passes an apple to Eve. The Tree of Life has been pricked over another tattoo, possibly an arch and checkerboard floor—Masonic symbols. The shamrock, rose and thistle symbolise Ireland, England and Scotland.

A love token, dated 1830. Beneath a tree, a man and woman, evoking Adam and Eve, enjoy a pipe and drink. There is also a heart pierced with darts, two stars and a dotted border. Stippling—producing an image with dots or pricks, the manner in which tattoos were applied—was frequently used to engrave convict love tokens.

Marion Telford was tattooed on both arms with people dancing, a ship, a fish, an eagle, religious icons and the names of loved ones. Telford was transported for seven years for robbery and arrived in Van Diemen's Land in 1851. Almost one year to the day later, she was granted permission to marry convict James Groundwater. Husband and wife were both thieves who'd been ejected from Scotland. When the couple settled in Bothwell, a small Edenic town in central Van Diemen's Land populated largely by Scots, Telford's Adam and Eve tattoo took on a rather ironic meaning: Marion and James had arrived in Eden.

Groundwater was not recorded as bearing any tattoos, but his criminal past may have been evident in scarring across his back: a result of twenty-five lashes for, of all things, stealing apples.

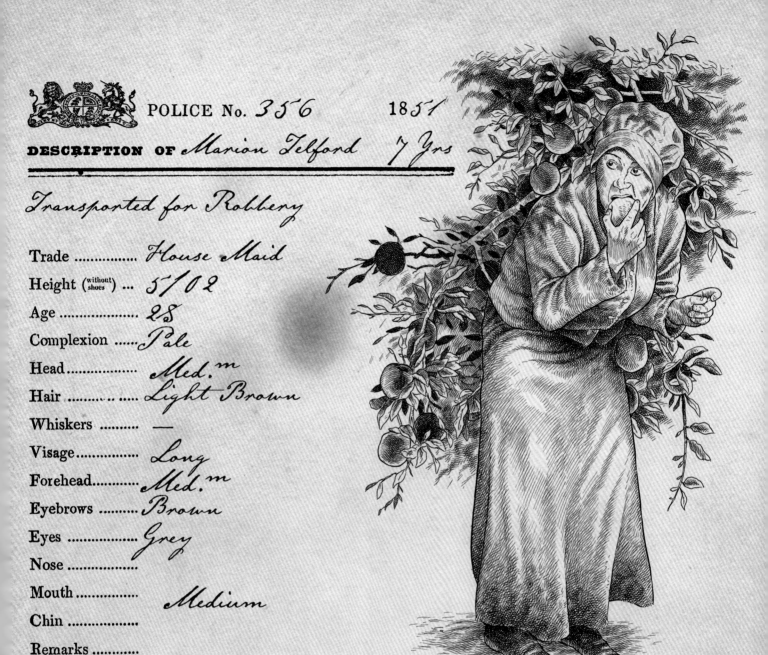

POLICE No. *356* 18*51*

DESCRIPTION OF *Marion Telford* *7 Yrs*

Transported for Robbery

Trade	*House Maid*
Height (without shoes) ...	*5/02*
Age	*28*
Complexion	*Pale*
Head.................	*Med.^m*
Hair	*Light Brown*
Whiskers	*—*
Visage...............	*Long*
Forehead...........	*Med.^m*
Eyebrows	*Brown*
Eyes	*Grey*
Nose	
Mouth	*Medium*
Chin	
Remarks	

Man + woman dancing on right arm
Ship C.M.B. fish above elbow right arm
Adam + Eve on left arm Cross G. Heart J.M.J
Eagle on same arm above elbow

ANCHOR

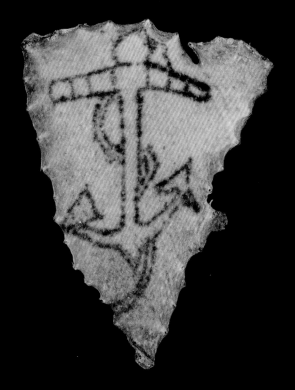

Human skin tattooed with a fouled anchor, circa 1850–1890.

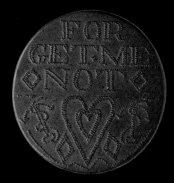

A love token attributed to thirteen-year-old William Mollet, transported to Van Diemen's Land in 1845 for stealing tea. The words 'FOR GET • ME NOT' are set among diamonds, a heart within a heart and two upside-down fouled anchors.

The anchor, an ancient symbol of hope, was the most popular of all tattoo motifs—anchors account for nearly ten per cent of male convict tattoos. The book of Hebrews in the Bible describes hope as 'an anchor of the soul, both sure and steadfast'. St Ambrose, a fourth-century bishop, said, 'It is this which keeps the Christian from being carried away by the storm of life.' For convicts transported to Australia, an anchor tattoo was a reminder to stay hopeful. Richard Franklin expressed his desire to keep his hopes up with a tattoo of a man carrying an anchor. Fillingham Morley was tattooed with an anchor and the words 'Hope supports us'. Sydney Harris declared the sentiment by tattooing the word 'hope' next to an anchor, his initials and 1832, the year he was convicted. John Bromley was tattooed with an anchor, the word 'hope' and the sentence 'Without hope man is nothing'.

With an accentuated tie bar and shank, an anchor could depict both an anchor and a cross. This image was known as an anchor cross, or *crux dissimulata*, cross disguised. John Ryan's record states: 'J Anchor Cross inside rt arm', which could have described a cross tattooed within an anchor or a cross tattooed beside an anchor, suggesting: 'John has hope and faith' or 'John has hope in salvation'. However, as a symbol can have more than one meaning and the recording process was not standardised, individual tattoo sequences are not easily interpretted. An anchor followed by a crown can symbolise 'hope in victory' or 'hope in sovereignty' but the 'crown and anchor' was also a well-known Navy emblem, a popular pub name and a dice game that incorporated playing-card symbols. Abraham Higham was tattooed with 'club, spade, diamond, heart, crown, anchor' on his left arm. Women with anchors are commonly found in tattoo descriptions and probably depicted the virtue hope.

The Christian virtues of hope, faith and charity are typically expressed as three women accompanied by an anchor, a cross and a heart. Patrick Quin was tattooed with a 'Woman & anchor', James Rushby a 'Woman & Cross', and James Meecham a 'woman with heart'. But the virtues were also expressed as just an anchor, a cross and a heart. John Day was tattooed with an 'anchor, heart & cross' on the inside of his left arm.

The most common anchor variation was the 'fouled anchor'—an anchor with a rope or chain entwining the shank. An entangled anchor at sea was bad news, and the fouled anchor motif may have been originally a symbol of resilience and perseverance. By the nineteenth century, the motif was most famously associated with the Admiralty. John Wilcox, a convicted boatman and sailmaker, was tattooed with a 'foul anchor' on his left arm.

Upside-down anchors expressed lost hope, in the same way that an upside-down cross symbolises a loss of faith. Thomas Connell, who was serving a life sentence for 'slightly' cutting the throat of his lover during a twelve-day bender, was tattooed with an 'anchor reversed', which may have portrayed his sense of hopelessness. It's also possible that in some cases an upside-down tattoo may have been accidental.

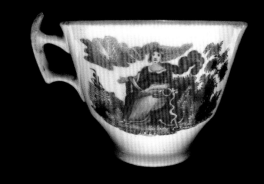

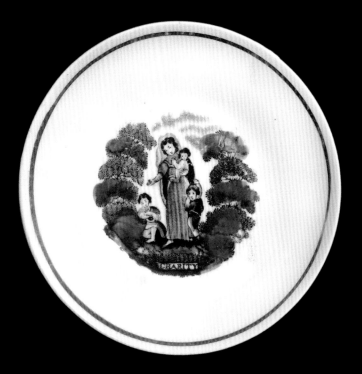

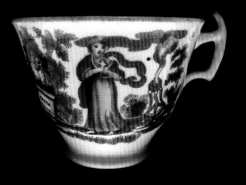

A Sunderland lustreware cup and saucer, circa 1840. Lustreware, named for its bright metallic glaze, carried many of the motifs tattooed on convicts. On one side of this cup Hope sits with a fouled anchor and motions to a ship. On the other side Faith clutches a cross. To her left is a censer burning incense and to her right is an open Bible on a plinth. Charity is depicted on the saucer, with three children.

For James Punt Borrit, the anchor tattooed on his right hand was probably a reminder to maintain hope in times when there was little hope to be had. In 1839, Borrit was charged with breaking and entering. He was transported to Norfolk Island for a fifteen-year term. After eighteen months in what he described as an 'Ocean Hell', he escaped in a whaleboat with eight other convicts. The gang endured many hardships before eventually landing in the New Hebrides. Borrit then travelled to America aboard a whaler, and then back to England. He was soon recognised, however, and returned to Norfolk Island, this time for life. In 1849, he stowed away on a merchant ship and, after nearly suffocating, was lucky to make it back to England alive. In England he was recognised yet again and rearrested. At his trial, Borrit stated 'for one original offence I have endured torments and privations worse than death itself', and he begged for 'justice tempered with mercy'. His cries fell on deaf ears and a sentence of six months imprisonment was handed down, along with yet another sentence of life transportation.

Despite the crushing judgment, it seems unlikely that the stalwart convict would have given up on attempting to reunite with his wife in London. Borrit was a seaman by trade, whose middle name 'Punt' is the term applied to a sturdy, dependable flat-bottomed boat, and he was equipped with an anchor to steady himself in stormy seas.

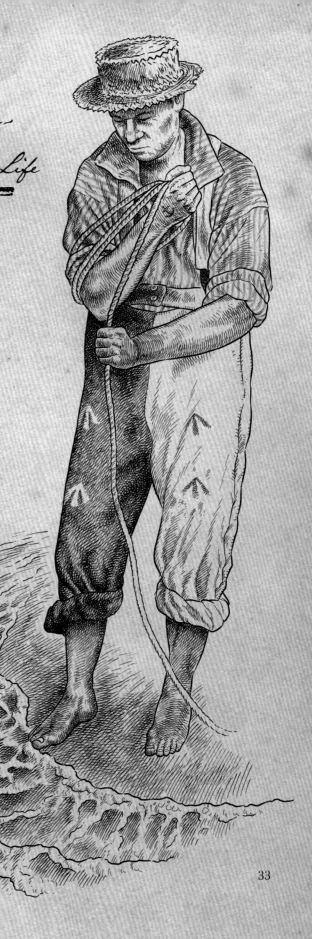

POLICE No. *19809* 18 45

DESCRIPTION OF *James Punt Borrit Life*

Stated ths offence,
Returning from Transportation

Trade *Seaman*
Height (without shoes) ... *5 | 8*
Age *33*
Complexion *swarthy*
Head *broad*
Hair *black*
Whiskers —
Visage *oval*
Forehead *broad*
Eyebrows *black*
Eyes *grey*
Nose *Med*
Mouth *medm*
Chin *M*
Remarks

Anchor rt hand
cut under lip left side

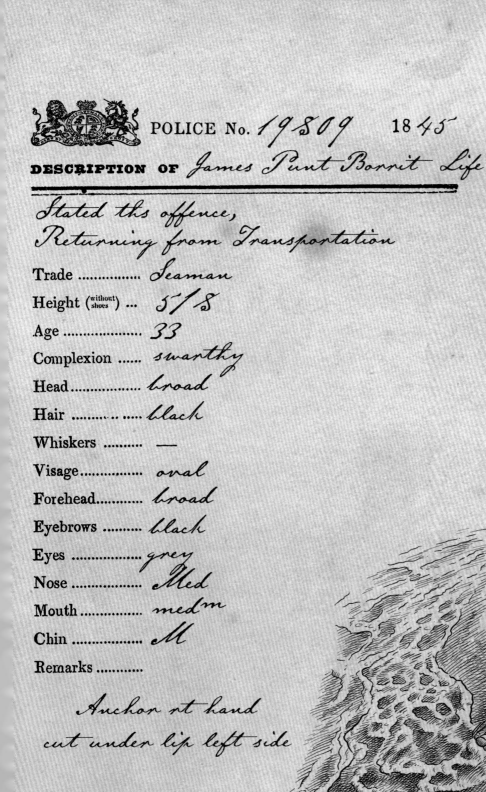

33

The busy bee and its humming hive—representing industry, cooperation and prosperity—was a popular emblem for British shops and pubs. For convicts sentenced to ganged labour for the betterment of the colony and treated as worker bees, tattoos of the bee and its hive take on a rather different meaning.

Records detailing the personal histories of convicts tattooed with beehives offer few clues as to why they would have chosen this potent symbol of enforced labour. Convicts tattooed with beehives were not recorded as beekeepers. Convicts with a history of stealing beehives were not recorded as having beehive tattoos. Some beehive bearers may have been paying homage to the city of Manchester, where the bee was revered as a mascot, but only one beehive-tattooed convict has been identified as hailing from Manchester. Beehive tattoos might have symbolised sanctuary or domesticity: Thomas Duncan preceded his 'Hive with bees' with his initials and those, most likely, of his family: 'T.D M.D.S.AJD. D.T.'.

In 1828, five convicts tattooed with beehives arrived in Van Diemen's Land aboard the *Woodford*. Their tattoos could have signalled an allegiance—the beehive was also a masonic symbol—but as the men were not tattooed with other more typical masonic imagery, it seems unlikely that they were masons. If the men chose the motif to mark their solidarity, it seems unusual that George Tomlinson, brother of one of the beehive bearers onboard, did not have a beehive tattoo too. The few convicts recorded as having beehive tattoos who were transported to Australia may have been expressing the virtue of working hard for the betterment of all as a moral principal or as a religious teaching. In his commentary on Proverbs 6:8, Titus Flavius Clemens, a third-century Christian theologian, wrote 'consider the bee and see how she labours'. Saint John Chrysostom

a bishop and preacher from the fourth and fifth centuries, declared: 'The bee is more honoured than other animals; not because she labours, but because she labours for others'. It was not uncommon for Georgian keepsakes illustrated with beehives to carry the words 'respect the giver'. A beehive was also used to symbolise a congregation united within the church. According to one legend, bees do not procreate but gather their young from flower buds—symbolising the Virgin Mary. Beeswax candles, the product of 'virgin labour', were used in church services. On account of their three-month hibernation period during winter, bees sometimes symbolise the three days Christ spent entombed.

Similarly the butterfly, which was also tattooed on convicts, was suggestive of birth, death and resurrection in its three phases, as caterpillar, chrysalis and butterfly. In the early nineteenth century, more than 200 crimes were punishable by death, including petty theft. Some convicts who were sentenced to death but received a reprieve of transportation may have been tattooed with a beehive or butterfly to symbolise life anew.

'**The British Bee Hive**', 1867. George Cruikshank produced the print when the working-class movement known as Chartism was lobbying for democratic reform. More than one hundred Chartists were convicted of protesting, and were transported to Australia. Cruikshank depicted an idealised British society in which the queen and royal family occupy the pinnacle, the armed forces the foundations, and the working class, or worker bees, the honeycomb in between. Convicts were not included

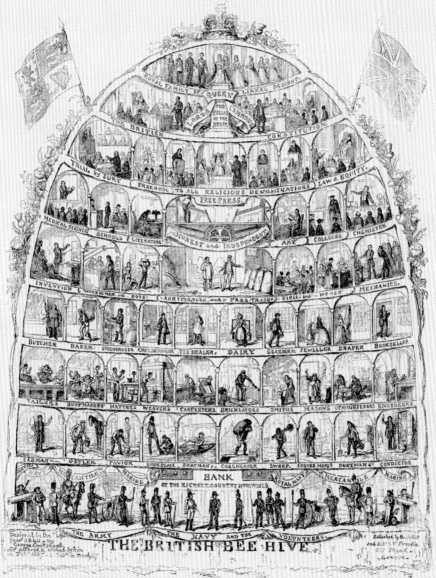

A PENNY POLITICAL PICTURE FOR THE PEOPLE,
WITH A FEW WORDS UPON PARLIAMENTARY REFORM.
BY THEIR OLD FRIEND, GEORGE CRUIKSHANK

John Elson was tattooed with a ring around his right little finger and several images on the inside of each of his arms, including a beehive and bees on his left arm. Elson, a bag snatcher, was transported to Van Diemen's Land for life, where his brick-making skills were put to use. For good behaviour he received a ticket of leave in 1836, which allowed him to own property, live where he liked and work for himself, albeit under the authorities' watchful eye. Elson's little hut, however, quickly became a safe haven for convict worker bees. In 1841, he was caught sheltering a man and woman 'of bad character'. His ticket was revoked and he was sentenced to a year's hard labour in chains. Just a few weeks later another convict was discovered sheltering in the hut. Elison copped another year in chains, and the official recommendation for his Royal pardon was revoked. After a few more years spent toiling for the colony, Elson was recommended for a pardon a second time. In 1846, he received his pardon, was released from prison, and was finally at liberty to pursue a life free from the demands of his Queen.

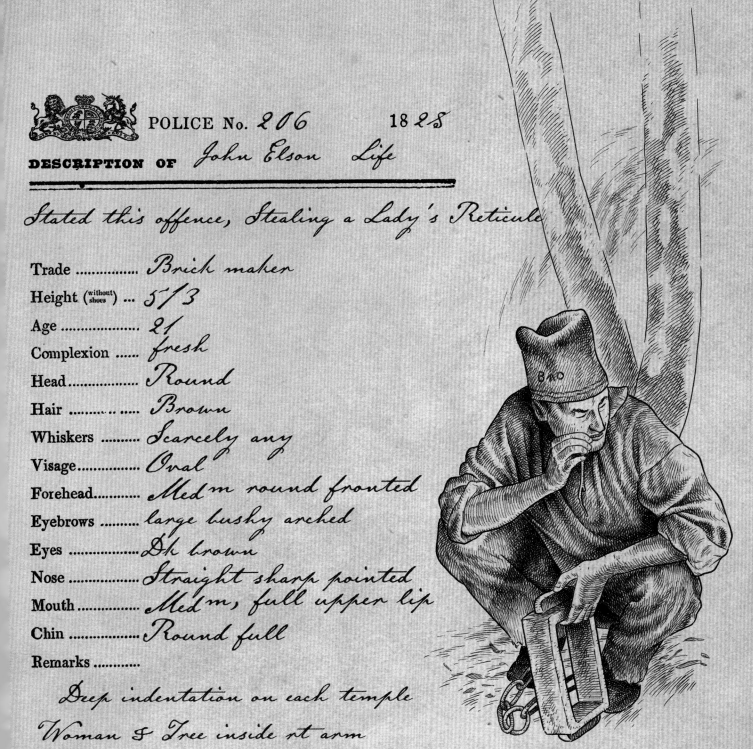

POLICE No. *206* 18*28*

DESCRIPTION OF *John Elson Life*

Stated this offence, Stealing a Lady's Reticule

Trade *Brick maker*

Height (without shoes) ... *5/3*

Age *21*

Complexion *fresh*

Head................. *Round*

Hair *Brown*

Whiskers *Scarcely any*

Visage............... *Oval*

Forehead............ *Med m round fronted*

Eyebrows *large bushy arched*

Eyes *Dk brown*

Nose *Straight sharp pointed*

Mouth............... *Med m, full upper lip*

Chin *Round full*

Remarks

Deep indentation on each temple

Woman & Tree inside rt arm

Bee hive and Bees, between two Bushes inside left arm.

Ring pricked on little finger rt. hand,

some pockmarks on the face.

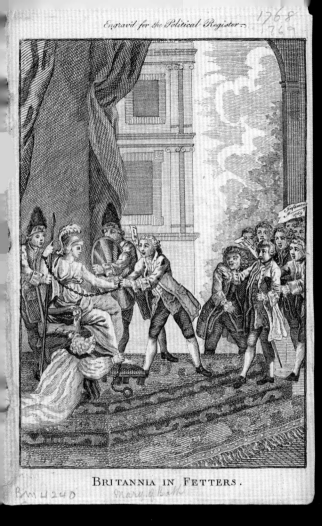

BRITANNIA IN FETTERS.

RM 4240 Mary of Bath

'Britannia in Fetters', 1769. In 1768, John Wilkes, a popular
writer and politician, was gaoled for libel. Riots ensued and
the Secretary of State, Viscount Weymouth, ordered troops
to fire upon the mob, killing seven and wounding fifteen.
Weymouth is depicted chaining Britannia's wrists, symbolising
the restrictions on civil liberties. A prelate shackles her ankles
and guards remove her armaments. The speech balloons have
been censored lest the publisher suffer the same fate as Wilkes.
In 1819, tougher penalties were introduced and libellers faced
a sentence of fourteen years' transportation.

Patriotic tattoos were popular among convicts who
had served in the army and navy. The most iconic
motif was Britannia. She first appeared in the second
century as a Roman warrior goddess, in a Corinthian
helmet and with an aspis shield, military standard and a
sceptre or javelin. Her accoutrements were modernised
in the nineteenth century to include the Union Flag and
trident, symbolising Britain's naval might.

Jeremiah Rahilly had Britannia pricked on his
right arm. Among his many other tattoos were a rose
and shamrock, also national emblems: the rose of
England, the shamrock of Ireland. When presented with
the Scottish thistle, they portray the union of the three
kingdoms in 1801. But Rahilly may not have been as
passionately nationalistic as his tattoos suggest: in 1838
he was courtmartialled for deserting his regiment.

Women were less likely than men to acquire
patriotic tattoos. But Bridget Oswald was an exception.
On her left arm were a rose, a shamrock, a thistle and a
slew of initials that might have honoured loved ones in
the service of their country.

Patriot symbolism increased in popularity following
the Napoleonic Wars. From the ages of convicts tattooed
with Britannia, it appears that men who were born
during the wars were more likely to have a Britannia
tattoo than those who served in the wars. When the
wars ended, in 1815, John Huckle was only three years
old. When his tattoos were recorded, when he was
twenty-one, they included Britannia, a sailor, several
flags and a crown.

Crown tattoos symbolised loyalty, royalty, victory
and sovereignty. Charles Woodland was tattooed
with a crown and 'GR III 1798', which appears to
have represented his king, George III's, quelling of
the Irish Rebellion in 1798. A crown can also convey
religious sentiment. George Apsey was tattooed with a

Crucific Crown flying angel'. Seaman Thomas Jones bore a crown, a unicorn and a lion. The unicorn is the national animal of Scotland, representing pride, purity and chastity. The lion symbolises England: royalty, courage and bravery. Together they appear on the royal coat of arms of the United Kingdom. Thomas Fitzallen was tattooed with a lion's head on each arm. Michael Robinson, a gamekeeper, had a lion and a monkey. Willem Pokbaas also carried the mark of a lion; not a tattoo but a mawled right arm, the result of an unfortunate encournter in his African homeland.

Patriotic motifs adorned some places of convict imprisonment and most official documentation, which may have caused some convicts to resent such imagery. Britannia and the English lion were even watermarked into the very paper on which convict tattoos were recorded.

A 'Bank Restriction' note, 1819. During the Napoleonic Wars, a large number of extra banknotes were printed to meet war costs, and the Bank of England's gold reserves diminished as people exchanged the notes for gold. The Bank Restriction Act was introduced to hinder that exchange, and smaller notes were printed as a substitute for coinage. The new notes were poorly printed and easily forged. Convicted forgers faced imprisonment, transportation or execution. As a protest, George Cruikshank produced a banknote lampooning traditional currency motifs. A noose shaped as the pound sign, chains from leg irons, a skull and the condemned adorned his note. A gruesome Britannia feasting on her supplicating subjects sits surrounded by transport ships. The note bears the signature of Jack Ketch, an infamous seventeenth-century executioner.

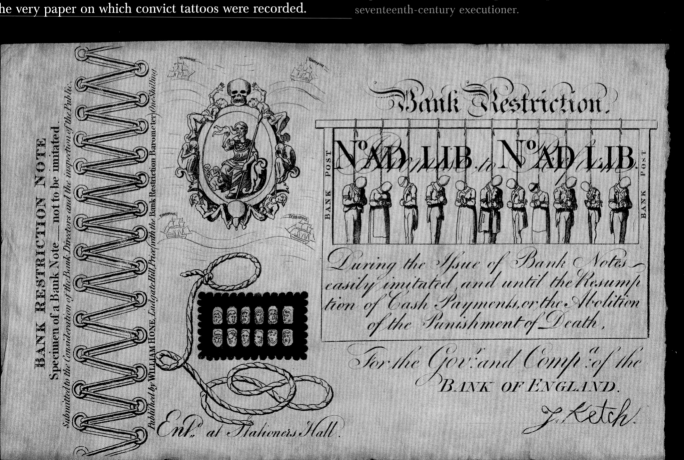

John Popjoy was tattooed with images that reflected a life spent at sea: an anchor, sailors, the virtue hope and a mermaid. Popjoy was transported for horse stealing and he ended up in Van Diemen's Land after serving time in New South Wales. In 1828, he was sentenced to time at the dreaded Sarah Island penal station on the rugged Van Diemonian west coast. During the voyage there from Hobart Town, convicts seized the *Cyprus* and booted the passengers off at Recherche Bay. A few convicts, including Popjoy, didn't join the mutineers and were left marooned with the passengers. With the help of convict Tom Morgan, Popjoy paddled away on a makeshift raft to raise the alarm. Popjoy was celebrated for saving the lives of the marooned men, women and children, but he also drew scorn for betraying his pirate chums. For his heroism he was awarded his freedom, and he returned to England in 1830, where he volunteered to give evidence in the trial of the *Cyprus* mutineers. His loyalty to King and country were expressed in his tattoos: the King's heraldic arms and Britannia. But the verse tattooed on his right arm also suggests devotion to his fellow seamen:

From rocks and shoals, and every hill,
may God protect the Sailor still.

Piracy carried the death penalty, and Popjoy's actions cost two of his ex-mates their lives. Popjoy drowned off the coast of France in 1833. His fate cast a rather tragic light on the verse tattooed on his right arm:

Rocks, hills and sands, and barren lands.
Kind fortune set me free
From roaring Guns, and Womens tongues,
O Lord deliver me.

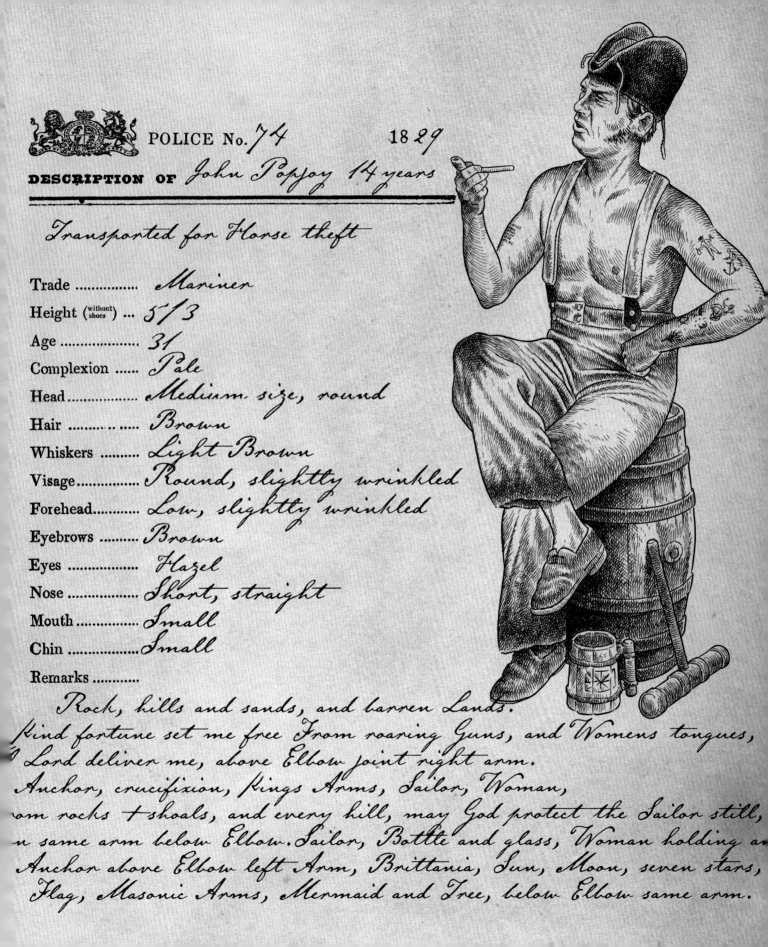

POLICE No. 74 1829

DESCRIPTION OF John Popjoy 14 years

Transported for Horse theft

Trade Mariner
Height (without shoes) ... 5/3
Age 31
Complexion Pale
Head Medium size, round
Hair Brown
Whiskers Light Brown
Visage Round, slightly wrinkled
Forehead Low, slightly wrinkled
Eyebrows Brown
Eyes Hazel
Nose Short, straight
Mouth Small
Chin Small
Remarks

Rock, hills and sands, and barren Lands.
Kind fortune set me free From roaring Guns, and Womens tongues,
O Lord deliver me, above Elbow joint right arm.
Anchor, crucifixion, Kings Arms, Sailor, Woman,
om rocks + shoals, and every hill, may God protect the Sailor still,
n same arm below Elbow. Sailor, Bottle and glass, Woman holding an
Anchor above Elbow left Arm, Brittania, Sun, Moon, seven stars,
Flag, Masonic Arms, Mermaid and Tree, below Elbow same arm.

BROAD ARROW

A double-sided Georgian lead seal embossed with the broad arrow and royal crown. Lead seals were used to fasten and identify goods ranging from bales of hemp and bags of sugar to bolts of cloth. John Shacklock was transported for fourteen years for embezzling cloth while working as a packer in the King's Yard, the naval dockyard at Woolwich.

In the seventeenth century, the broad arrow was adopted as an insignia by the English government to mark its property for identification. It was scrupulously stamped on all manner of items from biscuits and boots to bridges and Bibles.

In 1867, the Royal Navy found itself in hot water when it was alleged that a midshipman had been lashed to a cannon and his nose tattooed with the broad arrow. Further hysterics followed in 1880, when the sons of the Prince of Wales were reported to have had their noses tattooed with the broad arrow. In each instance the tattoos were temporary, and the men were observing a naval tradition, which, it was said, was practised by 'nearly every other sailor'. To commemorate an event, such as crossing the equator, seamen succumbed to a temporary tattoo: 'a slight cut is made with a penknife down the nose and two transversal cuts, a little gunpowder is rubbed in and the "decoration" is visible for a few weeks or months'.

But the act of indelibly branding Brits with the broad arrow had, in fact, been put into practice some forty years earlier when a sea captain tattooed a boy's backside with a broad arrow and the letters P.B. The letters, an abbreviation of 'prentice boy', also stood for 'prisoners' barracks' and were commonly stencilled on convict clothing. Irish nationalist John Mitchel wrote defiantly in his journal, 'The Queen's arrow may be branded on my garment [but] they cannot brand it upon my heart.' Scottish convict Angus Mackay was tattooed with the broad arrow along with his name. Mackay may have been having a joke at his own expense or undermining the government's assertion over his body.

In a similar instance of sardonic body modification, George Hall had chains tattooed around each of his wrists. Edward Dodge anticipated his time in chains with the tattoo of 'a man in fetters'. William Gardner

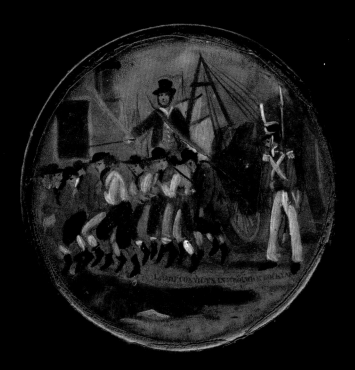

A papier-mâché snuffbox inscribed 'Gang of convicts on Woolwich Dockyard', circa 1820. Two broad arrows feature on the jacket worn by the convict nearest to the soldier.

was tattooed with a 'boot and chain' and, as fate would have it, his very first offence was trafficking his boots. But unlike the boot in chains of his tattoo, he got away with two months' hard labour 'out of chains'. Fifteen-year-old James Clark was tattooed with the stoic words 'strike me fair and strike me firm and do your duty' across his left shoulder and arm. Clark's tattoo was positioned to address the flagellator in an empowering display of bravado. William Bartlett was tattooed with a signal sent by Vice Admiral Lord Nelson from his flagship *HMS Victory* as the Battle of Trafalgar was about to commence in 1805: 'England expects every man to do his duty.' But just what Bartlett saw as every man's duty is not something we can know.

The royal crown was another symbol used to mark British property. It was also a popular tattoo; some convicts tattooed with crowns and sentenced to hard labour may have felt themselves reduced to one of the government property tools that they worked with.

The idea of branding people as government property appealed to some. An Englishman wrote to his local paper suggesting all soldiers be tattooed with a crown or broad arrow to prevent deserters going undetected. King George III had, however, already adopted a measure to deal with this: tattooing deserters with the letter 'D'.

A nineteenth-century double-sided tool for branding government property with the broad arrow and crown. Branding tools were also heated or dipped in boiling tar to mark livestock. For stealing sheep branded government property in 1820, convict Thomas Bailey was sentenced, in Launceston, to death.

Shepherd Angus Mackay arrived in Van Diemen's Land in 1850, to serve seven years for sheep stealing. Only two of Mackay's tattoos were recorded in full: his name and a broad arrow, a symbol regularly printed on prison garb but rarely pricked on skin.

Mackay received a conditional pardon in 1855 for his near blemish-free record. In 1881, however, he was involved in another sheep-duffing case, this one involving brand tampering. Mackay escaped prosecution, but a few weeks later he was done for stealing sheep and slapped with another four-year term. The last entry scrawled across his record reads 'application for an old age pension'. It is likely that Angus and his broad arrow faded away in a government depot for the infirm, like so many other worn-out colonial relics.

POLICE No. *27981* 18*53*

DESCRIPTION OF *Angus Mackay* *7 years*

Transported for sheepstealing

Trade *Shepherd*
Height (without shoes) ... *5/4*
Age *21*
Complexion *Fresh*
Head.................. *round*
Hair *Dark Brown*
Whiskers *none*
Visage................ *round*
Forehead............ *med*
Eyebrows *Dark Brown*
Eyes *Grey*
Nose
Mouth *Medium*
Chin
Remarks

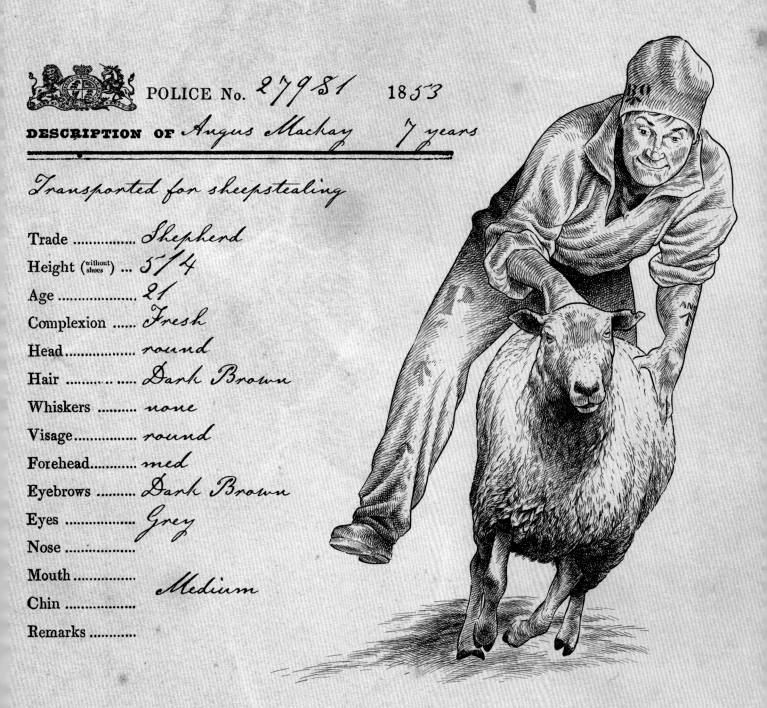

Angus, Broad Arrow, several blue left arm

45

CROSSED PIPES

A love token attributed to a sheep thief named Charles Betts, dated 1849. A glass and crossed pipes are encircled by a zigzag pattern, five dots and the name 'CHARLES BETTS'.

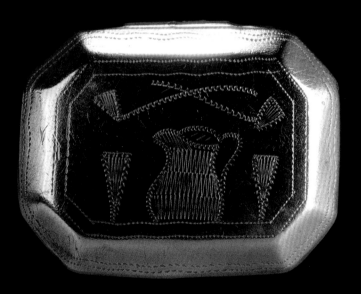

A brass tobacco box, circa 1800. The engravings, completed in wrigglework style, depict crossed pipes, an ale jug and glasses. Convict George Vinge was tattooed with the same motif: 'pipes Jug Glasses'.

Tobacco was introduced into Europe in the mid-sixteenth century. At first it was costly, and was smoked primarily by the elite, typically in expensive silver pipes. As it became more affordable its popularity increased and cheap clay pipes became common. Smoking soon became an activity associated with drinking, and by the seventeenth century images of crossed pipes adorned pub walls, pub signboards and publicans' currency tokens. Pipes were also popular tattoo motifs, frequently appearing with drinking imagery. They account for about two per cent of male convict tattoos. Samuel Green was tattooed with '2 pipes Decanter & glasses & Pot'. Ann Lee had a 'Jug Glass & pipe'. As well as signalling good times, the humble pipe symbolised intellectualism, sexuality, vice, peace and affluence.

Tattoos of crossed pipes along with glasses and other drinking imagery may have commemorated a coming-of-age such as a sixteenth birthday, although boys as young as ten are recorded as having such tattoos. Peter Burne, a self-professed teetotaller and prohibitionist, claimed that one notorious London pub emblazoned with crossed pipes, a jug and glass, served boys as young as twelve, who puffed and supped all day long, despite the legal drinking age being sixteen. According to Burne, some of the lads were later transported to Australia.

In 1819, it was estimated that up to ninety per cent of the colonial working classes smoked, and by 1832 only a little more than half. Convicts, however, were described as 'almost all' being 'determined smokers'. But tobacco was restricted and in order to obtain it some convicts resorted to theft and others to murder. Over time the authorities relaxed their view on convicts craving 'a gage of fogus', and by the 1860s tobacco was being issued daily at Port Arthur.

As a general rule, alcohol was also prohibited and convicts were not allowed in pubs, but preventing them from drinking proved impossible. Convict memoirist Jorgen Jorgenson noted that Van Diemonian pubs were filled with convicts night and day and it was often dangerous to walk the streets, even in the daytime.

The diagonal crossing of pipes, 'in saltire', may have been decorative, signified unity or alliance, commemorated an event or was intended to add an air of defiance as has been attributed to other crossed motifs, such as crossed swords and skulls with crossed bones. Other depictions of pipes included men and women smoking. Seaman James Leary was tattooed with a sailor smoking and a sailor exclaiming, 'Grog O!'. James Allen was tattooed on his left arm with a

mug, glass and a man puffing away. For Allen the tattoo may have held greater significance as he was a pipe maker by trade.

Some convicts paid tribute to other recreational interests. Henry Winter was tattooed with a 'bat & ball', and Richard Aspden was tattooed with a 'hare and hound'. Both these men were, at one time or another, punished for smoking or drinking. Some thirteen per cent of convicts tattooed with pipe paraphernalia had been charged with tobacco-related crimes. Crimes relating to alcohol were commonplace. Sarah Sheldon, tattooed with a 'woman and man holding bottle glass and pipe', was such a notorious tearaway toper that she was deemed 'an improper person to be in a family with young children'.

Graffiti of a man smoking a pipe, on a cell wall in the Bothwell Watch House, Van Diemen's Land, circa 1840.

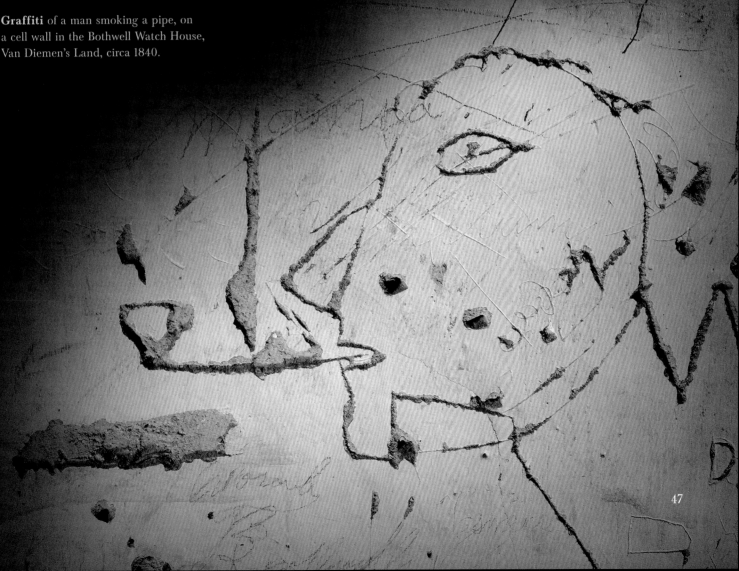

Pickpocket Peter Killeen 'committed nearly every offence imaginable', according to the Van Diemonian press. He served time in some of Australia's most notorious hellholes: Moreton Bay, Cockatoo Island, Norfolk Island and Port Arthur. Tattooed on his right arm was a bottle, a glass, crossed pipes and the words 'here's luck boys let us finish'. Despite the words of camaraderie, Killeen could not be trusted by his drinking buddies. In 1856, he narrowly avoided execution after he robbed a drunk and bought tobacco with the proceeds. In 1876, he was done for robbing another drunk and copped another seven years. Twelve years later he swindled a blind man out of tobacco using counterfeit coins. By this time Killeen was in his eighties. He spent his final days in the clink—his tattoo perhaps serving as a cruel reminder of a life gone up in smoke.

DESCRIPTION OF Peter Killeen 7 years

Transported for Stealing from the person

Trade Brick Maker & Groom

Height (without shoes) ... 5/6

Age 29

Complexion Fresh

Head oval

Hair brown curls in front

Whiskers brown

Visage long

Forehead perpend'

Eyebrows L Bro

Eyes Grey

Nose large

Mouth Small

Chin Square

Remarks

I I J M x. Stafford Rose thistle shamrock.
I I inside ring & anchor beneath on left arm
Bottle glass & crosspipes
here's luck boys let us finish rt arm

CRUCIFIX

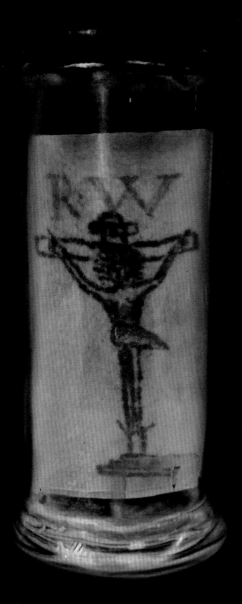

Human skin tattooed with an altar, a crucifix and the initials R W, circa 1800–50. Sailor and novelist Herman Melville wrote: 'The Roman Catholic sailors on board had at least the crucifix pricked on their arms, and for this reason: if they chanced to die in a Catholic land, they would be sure of a decent burial in consecrated ground, as the priest would be sure to observe the symbol of Mother Church on their persons.'

'Ye shall not make any cuttings in your flesh for the dead, nor print any marks upon you: I am the LORD'. Some people take these lines from the Old Testament to be a condemnation of tattooing, others a warning against pagan practices, specifically a mourning ritual involving body scarification. In the New Testament, Paul states: 'From henceforth let no man trouble me; for I bear on my body the marks of the Lord Jesus.' Paul's words have also been interpretted in various ways, but whether or not Paul was tattooed, tattooing has persisted among Christians for centuries. Christian pilgrims customarily acquired a cross tattoo on completing a pilgrimage to the Holy Land. And approximately five per cent of tattooed male convicts bore an image of a cross or crucifix.

A basic cross consists of a vertical stroke intersected by a horizontal stroke, but a Christian cross was also depicted as an X. James Jones bore a cross on his right arm, an X on his left hand and a crucifix on his left arm.

Religious tattoos expressed the bearers' beliefs; they also symbolised redemption, absolution and parallel suffering. John Grigg had Jesus' last words, 'Eli Eli lama sabachthani?', which translate as 'My God, My God Why hast thou forsaken me?', tattooed next to a crucifix on his left arm. Joseph Which was tattooed with a crucifix and the letters I.H.S., followed by his initials and those of his wife, Mary. The letters I.H.S. are commonly seen in conjunction with a crucifix— they are the first three letters of Jesus' name in Greek. Eliza Roberts was tattooed with a crucifix and I.N.R.I., a Latin abbreviation of 'Jesus of Nazareth the King of the Jews'. Crucifix tattoos were more prevalent among Irishmen than Englishmen and least prevalent among Scotsmen. They were hardly ever tattooed on women. That Jesus was crucified with two thieves may also have held significance for some convicts. Samuel Dutton,

himself a thief, was tattooed with 'Christ Crucified between two thieves' on the inside of his left arm. Dutton might have found comfort in the thought that, like the Good Thief, he would join Jesus in paradise.

Some people believed that the protection provided by a crucifix was absolute and a crucifix-toting convict could not be flogged. John McCarthy, however, was severely flogged. In a gruesome reflection of the angel holding a cup to catch his crucified saviour's blood that was tattooed across his chest, McCarthy's boots filled with blood as he hung from the flogging triangle. Nevertheless, the belief in the crucifix's power to protect persisted among British soldiers into the twentieth century.

Despite the prevalence of Christian symbolism in convict tattoos, Bishop Francis Nixon, the first bishop of Van Diemen's Land, suspected that many convicts abandoned their faith the minute they acquired their freedom. Some might have used religious tattoos to ingratiate themselves with their superiors, others to undermine them. George Dakin's hand was tattooed with Proverbs 14:9—'Fools make a mock at sin'—the perfect foil when saluting a disdainful superior. Stephen Kelly was tattooed with a crucifix and his initials on his right arm. On his left were his initials and an upside-down crucifix, possibly expressing a loss of faith, although Kelly, a Roman Catholic, may have been referencing the cross of Saint Peter, as Peter was crucified upside down. William Langham's record appears to state that he was tattooed with 'part of a crucifix' on each arm. Langham may have been tattooed with two halves of a crucifix that could be made whole by joining his arms—and broken by separating them—to express his fluctuating faith. Some of his other tattoos, however, were explicitly subversive: on his right breast was 'catch me', on his left breast 'fuck me'. Richard Sutton was tattooed with a heart and two devils. John Woods, a professed Protestant was tattooed with a 'Hindoo God', more likely a souvenir from sea service abroad than the result of a religious conversion.

Human skin tattooed with an altar, a crucifix and the letters I.H.S., early nineteenth century. The skin is thought to be from the body of Thomas Williams or John Bishop, both infamous burkers. Also known as body snatchers and resurrection men, burkers traded in cadavers for anatomical research. During the course of his twelve-year career, Bishop claimed to have sold between 500 and 1000 bodies. In 1831, the pair were executed for murdering a fourteen-year-old boy. Bishop was dissected in the very hospital he intended to offload his victim. A third gang member, James May, was transported to Van Diemen's Land. May was not tattooed, but, in a ghoulish twist, his record states that he was a butcher.

John Pearce was tattooed on each of his inner arms with religious imagery, drinking and smoking motifs and human figures. Pearce was caught with stolen books after robbing a church, and he was sentenced to fourteen years' transportation for the rarely recorded crime of sacrilege. He protested his innocence, stating, 'I was charged with stealing two books, I never saw the church.' His left arm was tattooed with a crucifix— perhaps Pearce committed his crime in blind faith.

POLICE No. *407* 18*26*

DESCRIPTION OF *John Pearce 14 years*

Transported for robbing a Church

Trade *Farmers Labr, Ploughman, Soldier*

Height (without shoes) ... *5/8*

Age *24*

Complexion *Dark*

Head..................

Hair *Dark brown*

Whiskers

Visage................

Forehead...........

Eyebrows *Dark Brown*

Eyes *D Brown*

Nose

Mouth

Chin

Remarks *The left ear stands off the head*
ears pierced
2 soldiers Man & Woman inside rt arm
Crucifix Man & Woman
pipes bottle & Glass inside left arm
last Joint Midl fr left hand crippled
lost one front tooth upper Jaw

'D' FOR DESERTER

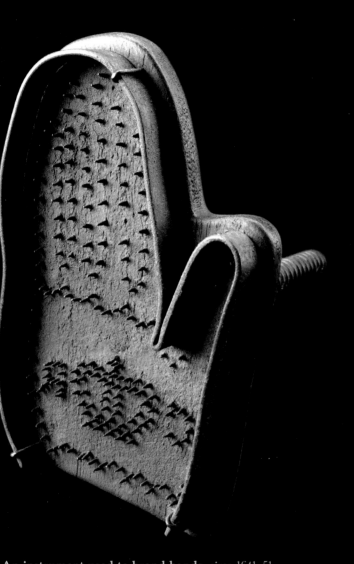

An instrument used to brand hands, circa 1641–51. Rather than branding an offender with a letter signifying his crime, the brand bears the royal crown and the letters 'CR', commemorating King Charles I. Brands, typically, were heated to burn and leave a permanent scar. In 1826, Joseph Clarke accidentally stabbed Paul Bishop in the head during a bout of drunken buffoonery at Hobart Town. Bishop died and Clarke was tried for manslaughter. He was 'sentenced to be burnt in the hand', and suffered a branding in the same manner as convicts branded at the Old Bailey in England.

In 1547, King Edward VI declared vagabonds were to be branded 'V' on the chest, fighters (fraymakers) 'F', and runaway slaves 'S' on the cheek or forehead. The law was repealed in 1550. But convicts tried at the Old Bailey were branded on the thumb with 'T' for theft, 'F' for felon or 'M' for murder until the late 1700s. Between 1699 and 1707, convicts could also be branded on the cheek. Victims faced the agony of a searing red-hot iron or, in some cases, a very cold iron. Branding was outlawed in 1829, but persisted in the British army until 1871.

A law passed in 1807 decreed that army deserters were to be tattooed with a 'D' 'two inches below and one inch in rear of the nipple of the left breast'. A one-inch high 'D' was cut from card, and an instrument consisting of 'six needle points fixed close together' was used to prick around the card to a depth of one-eighth of an inch. In 1841, a British doctor suggested a tool be manufactured to speed up the 'very painful' process. The following year the army introduced spring-loaded brass instruments with spiked D-shaped heads. A quarter of a pound of indigo and two sticks of Indian ink were mixed with water, which was then rubbed over the wound. The humiliating mark was designed to last a lifetime, preventing deserters going undetected or re-enlisting. Offending soldiers were branded 'BC', for 'bad character'. Women found loitering around army camps could be branded, have their left arm broken or even be executed.

Branding deserters wasn't always successful. Thomas Carey deserted on three occasions, netting three 'D's. His brands may have aided in his recapture but they didn't appear to deter him from running. In some instances the 'D' was disguised. Four soldiers transported to Australia in 1844 tattooed over their brands with an appropriately patriotic Union Jack.

Jeremiah Rahilly attempted to conceal his 'D' with a mermaid tattoo. James Hamilton, branded twice, purported he had merely 'tattooed himself for his own pleasure'. He was not believed.

A poorly tattooed 'D' could fade or be removed. An order issued in 1851 decreed medical officers were to carry out the procedure to ensure the job well done, and a log was kept detailing deserters and the condition of their 'D' tattoos. Of the estimated 1051 deserters transported to Van Diemen's Land, 800 are recorded as branded.

Some people viewed branding as barbarous and counterproductive as a disincentive to new army recruits. Others felt it a cost-effective punishment 'done with far less pain than is suffered by many soldiers and sailors who get themselves tattooed'. The navy, however, did not endorse branding, and not every soldier had experienced the prick of a tattooist's needle. One British doctor wryly suggested that the community would be better served if drunkards were branded 'D' instead.

Human skin bearing a 'D' for deserter. In 1850, in New South Wales, deserter Daniel O'Neil was branded 'D'.

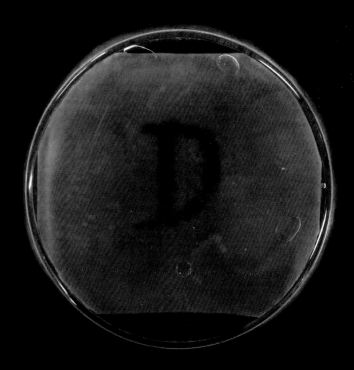

Branding instruments manufactured by John Weiss and Son of London. Medical officers used these to tattoo army deserters.

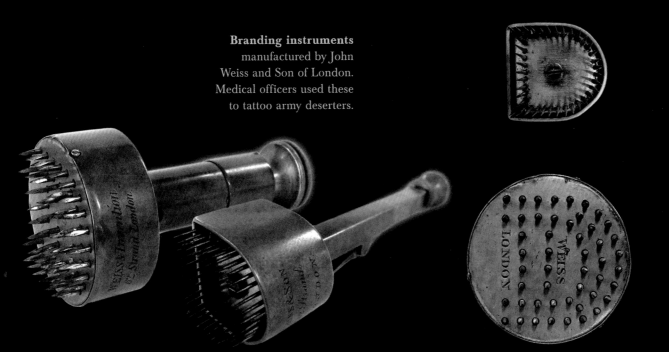

55

William Beale was charged with desertion in 1840, after just one day's absence from the 32nd Regiment. He was court-martialled in Canada, branded 'D', and sentenced to seven years in Van Diemen's Land. What kept Beale from his unit on that fateful day is not known; common excuses included escaping harassment or unfair treatment, taking up with a lover, being detained unavoidably, being drunk, absconding on a whim or just shirking duty. Perhaps Beale was inclined to be a little indolent, for, aside from being branded a deserter, the gaoler declared him a 'bad soldier' and the ship's surgeon-superintendent labelled him 'a dirty slovenly fellow'.

POLICE No. *908* 18*41*

DESCRIPTION OF *William Beale* *7 years*

Transported for desertion,
absent one day

Trade Labourer, Ploughman, Soldier

Height (without shoes) ... 5'9

Age 23

Complexion Florid

Head Long

Hair L' brown

Whiskers " "

Visage Long

Forehead High retreating

Eyebrows Lt Brown

Eyes " Brown

Nose very Large

Mouth

Chin medium

Remarks

4 finger left hand lost
scar on Breast
a Soldier Branded D on left side

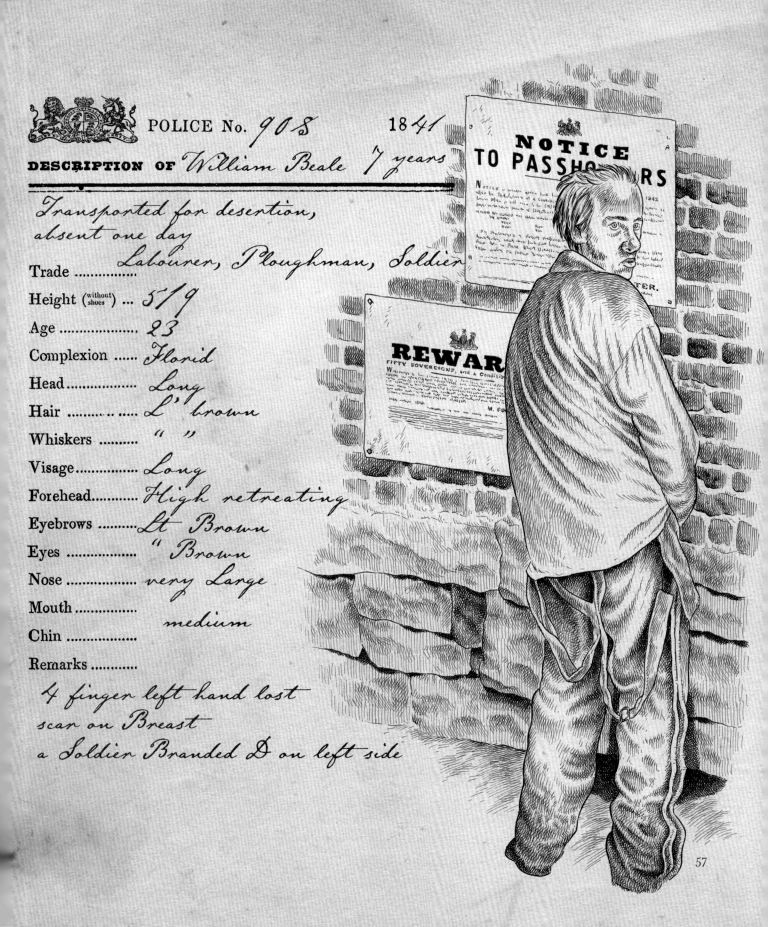

early five per cent of tattooed male convicts bore dots—on the arms, torso and face, but mostly on the left hand, which suggests that many dot tattoos were self-administered.

In August 1828, Edward Greyson was spotted rifling through passengers' pockets on a London-bound coach. After making off with a handkerchief, the fifteen year old was arrested. In court, it was revealed that Greyson belonged to a gang of youths who, on account of their number, called themselves the Forty Thieves, a likely nod to the ancient Arabic folktale. The following month, the court learned that gang members identified one another by 'secret marks' pricked into their skin with gunpowder. When more boys were nabbed in October, the mysterious mark was revealed as five dots tattooed between the thumb and forefinger. The authorities decided that offenders tattooed with the quincunx configuration should be transported across the high seas and the gang disbanded. The Forty Thieves, however, proved formidable.

By the 1830s several chapters of the gang were reported to be operating in England; some had even popped up overseas. Little more was heard of the Forty Thieves members transported to Australia. When the *Elizabeth* docked in Van Diemen's Land in 1832, Surgeon-Superintendent William Martin warned that among the youths on board were gang members, and that the identifying tattoo could be five, seven or nine dots due to rival gangs adopting similar marks. But, according to the records, just six of the 220 *Elizabeth* convicts were tattooed with dots, and only two on their hands. And James Deering's seven dots, accompanied by a half moon, was more likely to have depicted the Pleiades constellation.

Some people doubted the Forty Thieves' very existence. One English gaoler declared it 'was all nonsense' and that tattooed dots were commonplace. It is likely that dots had a variety of meanings, and that many dot tattoos were simply decorative. Joseph Hadley was tattooed with eighty-six dots in groups across both arms. James Sutton had just one, tattooed on his left middle finger. Jon Walters' six dots were in the shape of a heart. The 'ten spots' on Henry Biddulph's left arm may have been blemishes acquired when working as a miller, dressing millstones. Bernard Trayner, with his five dots, arrived in Van Diemen's Land nearly ten years before the Forty Thieves were first mentioned in the British press.

Five dots tattooed on the webbing between the thumb and forefinger have, however, endured as a criminal insignia, representing allegiance, time in prison and a convict hemmed in by four guards or four walls. According to nineteenth-century criminologist Cesare Lombroso, a quincunx of dots on the wrist indicated progression to the 'second degree' of a criminal network.

Following the arrest of incessant thief John Hall at Huntington, England, in 1852, the press declared the 'organised gang of forty thieves broken'. Nevertheless, thieves, and dots, continued to arrive in Australia.

Human skin believed to be from the left forearm of a Frenchman, circa 1850–1920. His tattoos include a man, a heart pierced with arrows, initials, a bracelet of dots and a bracelet of diamonds with a heart. Other patterns, including a triangle, are formed with dots, dashes and crosses. Similar designs can be found in convict records and convict graffiti. Running vertically down the skin are the words 'Mort Aux Vaches', 'Death to the Cows'. The phrase is believed to have originated as an insult directed at officers during the Franco–Prussian War. It was also expressed symbolically as three dots tattooed between the thumb and forefinger

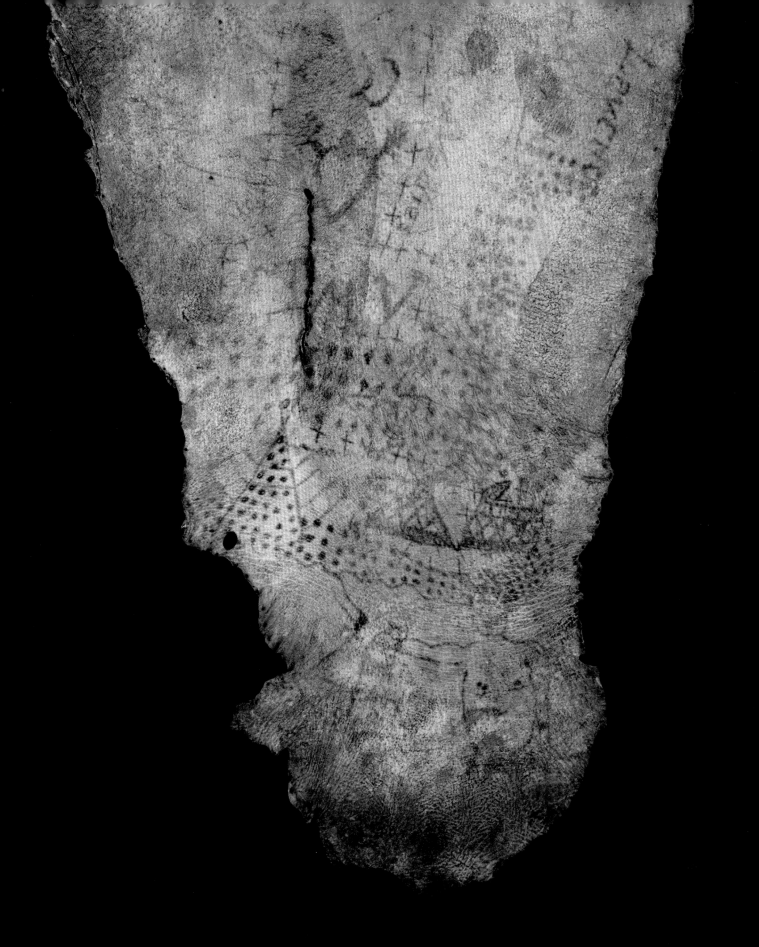

Running the length of John Lancaster's one arm was a spray of tattoos including drinking imagery, a constellation, the initials of loved ones and the infamous five dots. When Lancaster was caught stealing cheese in London in October 1828, he became one of the first of the Forty Thieves to be identified by the 'five blue spots' tattooed on his hand. He was sentenced to seven years in Van Diemen's Land, and later sent to a road gang for bad behaviour. After being accused of 'indecent and improper conduct' with three other convicts, two of whom were tattooed with dots, he was transferred to another road gang. As road gangs typically comprised forty men, it would be safe to say that Lancaster was as familiar with the arrangement as with the back of his hand.

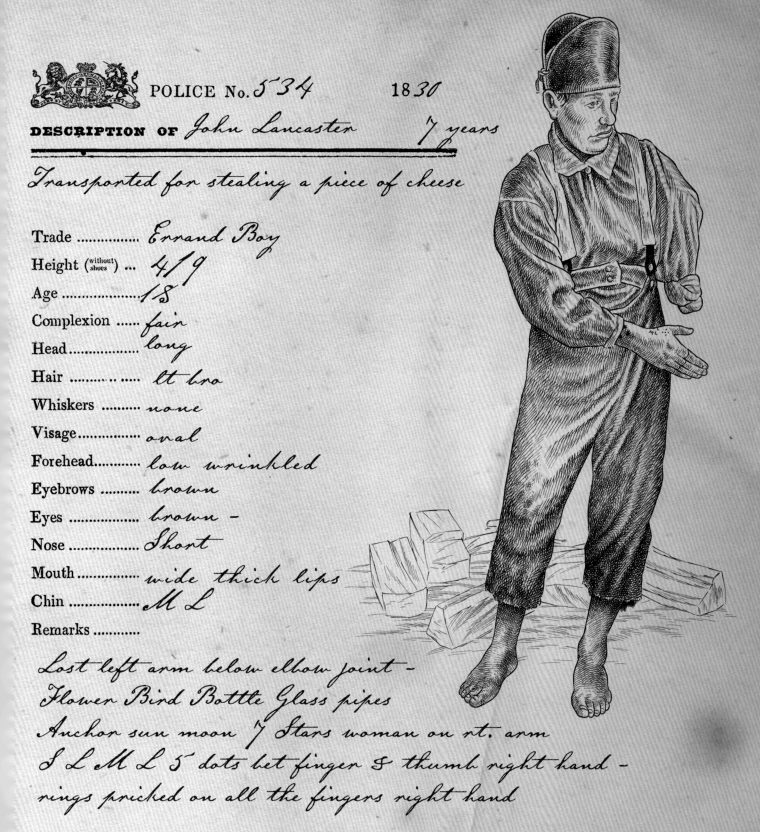

POLICE No. 534 1830

DESCRIPTION OF *John Lancaster* *7 years*

Transported for stealing a piece of cheese

Trade	Errand Boy
Height (without shoes)	4/9
Age	18
Complexion	fair
Head	long
Hair	lt bro
Whiskers	none
Visage	oval
Forehead	low wrinkled
Eyebrows	brown
Eyes	brown –
Nose	Short
Mouth	wide thick lips
Chin	M L
Remarks	

Lost left arm below elbow joint –
Flower Bird Bottle Glass pipes
Anchor sun moon 7 Stars woman on rt. arm
S L M L 5 dots bet finger & thumb right hand –
rings pricked on all the fingers right hand

DOVE

Approximately two per cent of tattooed male convicts were adorned with birds, and the most popular bird was the dove.

The dove is most famously associated with the story of Noah's Ark. The image of a dove clutching an olive branch, symbolising God's forgiveness, has become a universal symbol of peace. Due to poor tattooing and the cursory manner in which tattoos were recorded, doves, other birds, twigs and sprigs can be difficult to differentiate. James Taylor was tattooed with a 'bird & sprig', James Bently a 'Dove & Laurel', Samuel Shone with both: a 'Bird & Sprig' and '2 dove Laurel branches'.

A dove with a palm branch or laurel can also symbolise victory. James County was tattooed with a 'bird and laurel', though having been twice transported it would appear that for him victory was in short supply. William Henry Fletcher Shaw was tattooed with a 'bird & branch', which may have depicted the Liver Bird, the mascot of Liverpool, his birthplace. James Bibby bore a 'dove holding a letter in his bill', a popular Valentine motif.

Doves were commonly tattooed in pairs and frequently with hearts. A pair of doves symbolises union, fidelity, marriage and reproduction. Tucked away on the inside of John McCullen's right arm were two hearts, two doves, his initials and the initials 'J.S.', probably those of his lover. John Saunders' doves appear to reference his partner and also his parents. Saunders' right arm was tattooed with the words 'Liberty the dearest of names', two doves, the initials 'J.S. W.S.' and cupid's bow primed to fire an arrow. His left arm was tattooed with the words 'Honour thy Father & Mother, Love' and two more doves. Three doves fluttering about the tree of life symbolised the holy trinity of the Father, Son and Holy Spirit. William Dorman's tattoos were recorded as 'Tree of Life 3 Doves' on his left arm. Thomas Bellamy was tattooed with 'a Bird on a Tomb Stone, wreath under it', a symbol of the soul of a deceased loved one.

Other varieties of bird tattoos include peacock and fowl. The many 'eyes' in a peacock's plumage symbolise resurrection and all-seeing divinity, while the bird itself represents immortality, due to a belief that its flesh does not rot. A cockerel symbolises vigilance and awakening. Thomas Bates was tattooed with a peacock and a cockerel on his chest, which proved tragically ironic when he drowned while bathing. Henry Palfrey, a notorious poacher, was tattooed with a peacock and an owl.

A pair of fighting cocks may have been tattooed as testament to a person's fortitude or recreational interests. A 'Man with a Gun over his Shoulder and Bird in his hand' was tattooed upon the aptly named Charles Wing. Thomas Jones' 'hen & chickens', a Christian symbol of Christ and his flock, were tattooed with the initials of his wife Lydia, and may have depicted his family—hen was a slang term for a woman.

An eagle, symbolising strength, glory, patriotism and a 'soaring spirit', was the perfect pick for patriot James Lynn, one of several hundred convicts transported for attempting to oust the British from Upper Canada in 1838. William Carder chose to memorialise his pain with a dying swan beside a bleeding heart. Charles Woodirvis bore a most potent symbol of repression: a birdcage. Noticeably absent in convict tattoo descriptions, however, is the swallow. The swallow was a celebrated symbol of resurrection and a safe return. It is possible that the generic 'bird' referred to in many records was a swallow, but, if so, it is surprising that with its distinctive forked tail and curved wings it wasn't described more accurately.

A love token dated 1797. A dove carrying a letter marked with initials flies above a plant, possibly a forget-me-not.

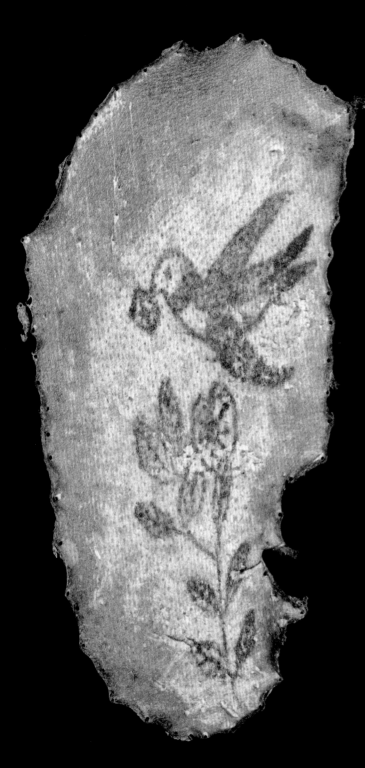

A gold locket pin, circa 1780. A dove, symbolising the soul, ascends to heaven clutching the end of a true-love knot. A second dove standing on a tree stump, which symbolises loss, holds the other end of the true-love knot. Doves were a popular symbol of enduring devotion due to the belief that pairs mated for life. Such unwavering loyalty may have been particularly appealing to transported convicts. Around the perimeter are the words: 'THE FARTHER I FLY THE FASTER I TYE', implying a bond strengthened by separation. The images are in sepia and macerated human hair.

Tattooed human skin, circa 1850–1900. A swallow with a letter in its beak flies above a plant, possibly a pansy.

Soldier Stephen Bryan was tattooed with motifs suggesting love and harmony: the English rose, the Scottish thistle, a cherub, a cupid, a heart pierced with darts and the words: 'Sailor once more at Anchor'. In 1835, however, Bryan lost his cool and, brandishing a loaded musket, threatened to blow a corporal's brains out. This was considered treason and was punishable by death, so it could be said that the fiery Irishman got off lightly when he was court-martialled, sentenced to three hundred lashes and transported to Van Diemen's Land for fourteen years. After arriving in late 1836, his rebellious course continued. Bryan was done for drunkenness, riotous behaviour, insolence, threatening language, demanding booze from his master, impersonating a free man, assaulting a constable and indecent exposure. In 1838, Bryan was inducted into the police force, which wasn't unusual for convicts, particularly if they had military experience. He was given free pardon and, befitting the dove tattooed on his right arm, he made peace with the world.

POLICE No. 2576 1836

DESCRIPTION OF *Stephen Bryan* 14 years

Transported for loading a musket with powder and both with intent to kill a Corporal

Trade Soldier, Labourer

Height (without shoes) ... 5/8

Age 27

Complexion Brown

Head Round

Hair Dk bro'

Whiskers Do thin

Visage Oval

Forehead M.H.

Eyebrows Dk Brown

Eyes D Brown

Nose Long

Mouth M.W.

Chin Long

Remarks

Sun 1/2 Moon 7 Stars Justice serpent –
Sailor once more at Anchor
Anchor on left arm –
Cherubim heart & darts Cupid dart
Rose & thistle Dove Woman S. T. &c on rt arm

The flowerpot tattoo motif originated as a representation of a potted lily, which was often seen in paintings of the Virgin Mary and symbolised the Immaculate Conception, the Annunciation and the Birth of Christ. The lily as a religious symbol fell out of favour during the Protestant Reformation of the sixteenth century, but the humble flowerpot lived on. Flowers account for two per cent of male convict tattoos, but flower types are rarely specified, and the lily does not appear to have been listed in convict records. Transcribers, it seems, did not deem flower descriptions noteworthy, or it may have been that flowers were tattooed in such a stylised manner that they defied identification. In a few instances, such as William Kitchen's 'rose in a flowerpot', the type was recorded. William Price was tattooed with '3 flowerpots'. He was also tattooed with patriotic imagery, and it is possible his pots contained the English rose, the Scottish thistle and the Irish shamrock. Or it may be just that Price, a ploughman and gardener, was partial to plants. John Hardman, a weaver, was tattooed with a basket and six flowerpots, possibly symbolising himself and the wife and four children noted in his record.

Flowerpots were frequently tattooed near hearts, initials and dates, suggesting perennial remembrance. Thomas Baggett was tattooed with a flowerpot, a man, a woman, his initials, those of his wife, Martha, and the year 1829. William Anderson was tattooed with initials, a flowerpot and 'SEPT 25 1829 21'—his arrest date and his age.

A flowerpot may also have symbolised separation, endurance, resilience and life constrained by circumstance. Samuel Buckley tattooed his own initials next to a flowerpot.

Over time, flower motifs became increasingly allegorical. Floriography, the 'language of flowers', was popular during the nineteenth century. The pansy with its heart-shaped petals had particular appeal and was used to express the notion 'think of me'. The word 'pansy' comes from the French *pensée*—thought. The botanical progenitor of the pansy was the viola tricolour, which also symbolised remembrance. It was known as 'heart's-ease' and 'love-in-idleness'. Such bittersweet sentiment might have had great appeal for transported convicts, but the pansy and its variants are not specified in the records.

Another popular flower motif was the forget-me-not, a small blue flower symbolising fidelity in love. Aside from Margaret Caroll's 'flower resembling a forget me not', it too escapes mention in the records. The evergreen laurel, sometimes in the form of a wreath or sprig, was often noted in convict records. It represents immortality, victory, chastity and eternity. It was also a decorative or commemorative motif. Francis Fitzmaurice had a scar encircled in a wreath, and Sarah Braerton carried the initials of a forsaken lover in a wreath tattooed on her right arm.

Convicts also bore tattoos of people holding flowers. William Taylor was tattooed with a 'woman with rose'. According to contemporaneous flower lore, a flower held upright expressed its allegorical meaning: a rose symbolised 'I fear, but I hope'. When held upside down it signified the opposite: 'neither hope nor fear'. Inverted flowers are not delineated in convict records either, but Alice Marsh's 'woman clutching a flower and handkerchief' suggests that some flowers were destined to wither, not bloom.

Human skin tattooed with letters and a pansy, believed to be French, nineteenth century. The tattoo can be read as: 'I think of A.H.'.

A love token inscribed 'Dear Charlott when this you see Remember me and bear me in your mind let all the world say what thay will spak of me as you find R * HoKlay 1834'. The token is attributed to Richard Oakley. Oakley and his two burglar accomplices, Richard Turner and Henry Rye, might be depicted in the flowerpot bearing three flowers. Both Turner and Rye also produced tokens decorated with flowerpots.

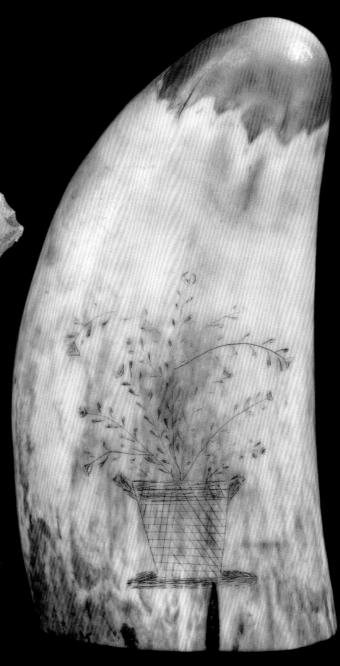

Nineteenth-century sperm whale tooth scrimshaw decorated with a flowerpot. Scrimshaw was particularly popular among whalers and sailors. Known examples bear many of the motifs described in convict records: ships, hearts, names and dates. Convicts also fashioned items such as dice, dominoes, apple corers and needles out of bone.

Elizabeth King was transported for shoplifting. She arrived in Van Diemen's Land in January 1841 to serve seven years. Tattooed on her right arm was a flowerpot, a heart and the initials S.K. and E.K., probably representing family members. The family tree, represented in her flowerpot motif, however, was tragically cut short. In April 1842, King was charged with murdering her illegitimate newborn baby girl. Infanticide was punishable by death, and King faced execution but, as the court could not ascertain whether her baby was born alive or dead, she was convicted of the lesser crime of 'concealing the birth' and escaped the gallows with a year's hard labour.

POLICE No. *144* 18 *41*

DESCRIPTION OF *Elizabeth King 7 years*

Transported for Felony

Trade *Farrier, servant, needle woman*

Height (without shoes) ... *5/4*

Age *21*

Complexion *Swarthy*

Head *Oval*

Hair *dark Brown*

Whiskers *—*

Visage *Long*

Forehead *High*

Eyebrows *dark Brown*

Eyes *Hazel*

Nose *medium*

Mouth *"*

Chin *Long*

Remarks

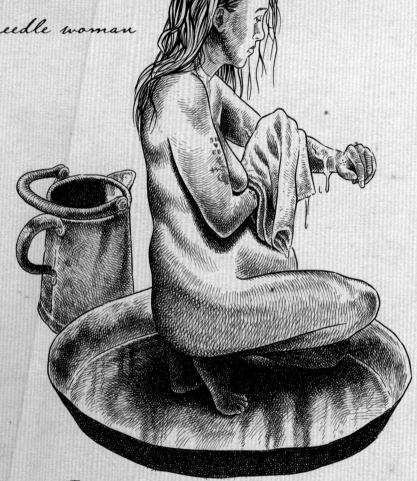

S K and heart E K Flower Pot
M I John R Haden L heart L on right arm.
L Heart A, Glass Port L H Anchor on left arm.
5 dots between forefinger and Thumb on left hand

HEART

The heart has been regarded as the source of emotion and character since ancient times. In the Old Testament, God said to Samuel: 'The LORD seeth not as man seeth, for man looketh on the outward appearance, but the LORD looketh on the heart.'

The origin of the heart's stylised shape is not known, but it has been attributed to a variety of sources including ivy leaves, male and female genitalia and the chalice containing Christ's blood. By the sixteenth century, the stylised heart had become established as a symbol of love. It was a popular tattoo motif: hearts account for about six per cent of male convict tattoos.

The sacred heart, a representation of Christ's heart, symbolises his love shown through his sacrifice, and is often depicted as a flaming, glowing or bleeding heart surmounted by a cross entwined with thorns. William Carder was tattooed with a 'bleeding heart'. Mary Smith's record includes a 'wounded heart', which may have described a heart broken in two or a heart skewered with a dagger, symbolising betrayal or loss. William Whitehead was tattooed with a 'hand heart'—a hand holding a heart represented love, union and piety.

Heart tattoos predominantly expressed undying affection and many were pierced with darts, referencing Cupid, the god of erotic love. Armed with his little bow and quiver, the airborne cherub fired his darts and instilled unbridled desire in his victims. Edward Payne was tattooed with a heart, darts, and the solemn verses:

> May the heaven protect & the powers above
> hanah brown the Girl that I Love.
>
> Cupids darts have pearced his heart
> & filled me with pain.
> I am afraid shall on my true love again.

With more than a touch of irony, William Allen had two hearts chained together. Allen also carried a slew of initials, nine of which ended in 'A', probably those of family members.

For convict tattooists short on equipment, pressed for time and sometimes lacking adequate space, abbreviating words would have been a necessity. Combining letters with the heart symbol expressed a statement of love. I ♥ L, meaning 'I love to this heart', was combined with initials and names as a declaration. Hannah McCarthy was tattooed with 'Mary McCarthy', the name of her sister, and 'I ♥ L' on her lower left arm. As a tattoo was permanent and the act drew blood, such a declaration could be considered a kind of blood oath. Tattooing the chest, near the heart, may have also added significance. Edward Saunders was tattooed with six hearts pierced with darts across his chest, and Joseph Noble was tattooed with a heart, a dart and the name of his sweetheart 'Eliza Jenkins' in the centre of his chest.

James Woolf was tattooed with a heart on the back of his left hand. William Green had a heart tattooed on his left thumb. The right arm of Paul Pierce was tattooed with a heart, darts and initials. He also had a 'large scar' situated on his arm, which might have cut through the array, creating a painful reminder of his separation from his family. But reunion was not long coming. Pierce's wife and seven children migrated to Van Diemen's Land within a few years of his arrival, and by 1830 they were all living together. Pierce, however, like many other convicts separated from their loved ones, appears to have suffered a change of heart and found love in the arms of another: in 1828, he was reprimanded for 'indecent and immoral conduct' with convict Elizabeth Frankland.

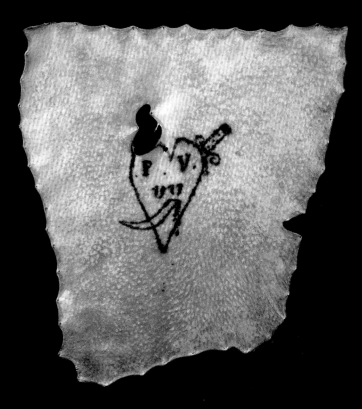

Human skin tattooed with a heart pierced with a dagger, and the initials P. V. VV. Believed to be French, circa 1850–1900.

A tobacco pipe featuring a heart, post 1850. Pipe bowls were imprinted with designs that correspond with the tattoos described in convict records, such as skulls, anchors, pugilists, crowns, flags, flowers and hearts.

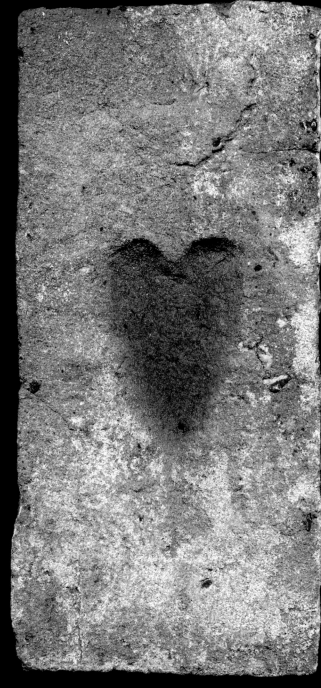

A brick, post 1850. Convicts produced bricks for the government and for colonists. Bricks were identified by an array of bonding marks termed 'frogs', such as the playing-card suits of clubs, diamonds, spades and hearts.

John Pilkington depicted his sorry plight in tattoos of a 'man in irons' and a heart with darts. Pilkington was accused of stealing cash and a leg of lamb from a couple who were riding along Pittington Lane in Durham, England. He denied the charges and after witnesses reported he was drinking in a pub at the time of the robbery, it looked as though he might get off. But after deliberating for just fifteen minutes, the jury returned a verdict of guilty, charged Pilkington with highway robbery and sentenced him to death. He responded by stating, 'I can face my God with a clear conscience', and, as if by divine intervention, his sentence was commuted to life in Van Diemen's Land. Pilkington never gained his freedom and never returned to the wife and two children he left behind. After a drunken game of cards he was stabbed in the chest with a knife that left a wound eight inches deep. He died, quite literally, of a broken heart.

POLICE No. *176* 18 *21*

DESCRIPTION OF *John Pilkington Life*

Transported for Highway Robbery

Trade *Stone Mason*

Height (without shoes) ... *5/5*

Age *21*

Complexion

Head...................

Hair *Brown*

Whiskers

Visage................

Forehead............

Eyebrows

Eyes *Grey*

Nose

Mouth

Chin

Remarks

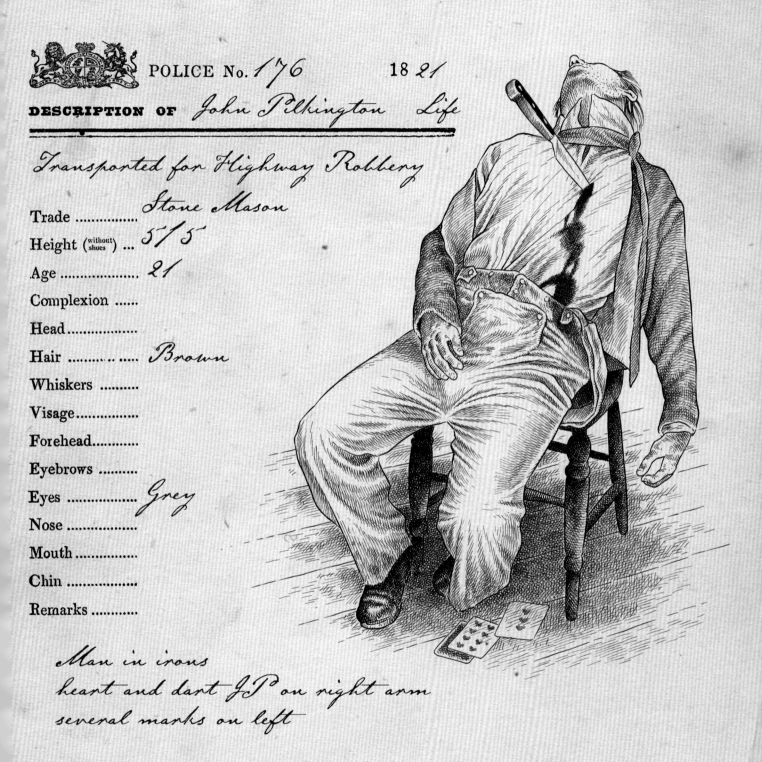

Man in irons
heart and dart JP on right arm
several marks on left

LETTERS AND NUMBERS

A love token dated 1838. Stippled beneath a flourish are letters and numbers: 'MY . HT IS . FD I CN NT . RE . I . LE MY . CE . TO WL . TO . CE J . MOORE AD . 24. They may be abbreviations of names and an age with a message comprised of abridged words such as HT for heart and LE for love.

A love token, dated 1827. The inscription may relate to a man aged twenty-four whose initials are W.P. and a woman aged nineteen whose initials are E.L. Æ is an abbreviation of the Latin *Aetatis*, meaning 'at the age of' or simply 'age'.

Letters of the alphabet were the most common tattoos. Over one-third of tattooed male convicts bore names and initials, almost half of which correspond with the bearer's name. Such tattoos could provide a means of identifying the dead. Reverend Robert Hawker, who dealt with shipwrecks near his Cornwall parish, felt sailors tattooed with their names showed great foresight and resignation to 'a mournful probability'.

Convicted waterman Joseph Moles was tattooed with his initials and a 'sailor holding bottle and glass'. William Kay, another seaman, was tattooed with the same motif and the letters 'J.S.'. The initials tattooed on Kay might have been those of his true name, as many convicts were transported under aliases. When Kay drowned in 1836, his body was quickly recovered and he was identified without the need to rely on a tattoo. In some cases, post-mortem identification was impossible, regardless of any identifying tattoos. When 'part of the back bone and ribs' washed up at Port Arthur in 1844, the authorities could not ascertain if it was the shark-masticated remains of absconders Charles McDonald, John Harris or Joseph Howens.

Letters also commemorated loved ones. Henry Davis, whose wife's maiden name was Ann Morris, was tattooed with a woman, 'A.M.', and the words 'my pride'. Names and initials were more popular among women: they account for about ninety per cent of female convict tattoos. But women were less inclined than men to be tattooed with the initials of their own name. Fifteen-year-old Bess Ward was tattooed with 'CS P A C G W B C J M JM C H W T JC' on her left arm and 'P G TC B W WW J W' on her right. One prominent scholar has suggested that strings of tattooed initials that did not match a woman's own name were the initials of her clientele, collected while working as a prostitute. Similarly, mismatched initials on men were

thought to be the names of prostitutes they frequented. At his sentencing, William Creamer was reported to be tattooed with the initials of a prostitute and so was twelve-year-old James Rutledge. Of five hundred female convicts identified as having a history of prostitution, twenty-five per cent were tattooed, nearly double the rate of other female convicts. Prostitutes were gaoled more frequently than other women and had greater interaction with soldiers and sailors. They were more exposed to the prevailing tattoo culture and so more likely to acquire tattoos, as were the men in the prison system and the armed forces.

Women, it seems, were more inclined than men to honour loved ones in their tattoos. Emma Fear appears to have been tattooed with the initials and prison terms of other convicts. On her right arm was 'M-A-D. 7 ys – F.A.B. E.HRB. 7 yrs = 6 Mo – EP – M.W. R.W. JG'. Her left arm bore 'A. Bright 14 ys – forget me not –'.

Some people may have been tattooed at the behest of others, making the link between tattoo and bearer more tenuous. Adam Smith, a *Bounty* mutineer, branded his Tahitian partner with 'AS 1789'. When the woman married another mutineer, her tattoo made for a more enigmatic reading.

Letters were sometimes accompanied by numbers. Richard Roberts' tattoo included his trial date: 'R. R. 10 yrs. Feby 4. 1839'. William Weeks had his name and birthdate: 'W Weeks born 20th April 1807'. And Thomas Woodley bore a eulogy on his left arm: 'Ann Carlott Born P. of Belfast Near Ramsey. I. of Man Died 1827. Aged 30'.

Convicts were also tattooed in Latin, Greek and French, typically to express religious sentiment. Francois Xavier Leclair was tattooed with 'Dieu Et mon droit'— God and my right. John Johnson was tattooed with 'Dieu veuille que je te revoir'—God ensures that I see you again. Thomas Powell didn't mince languages, letters or numbers—he was tattooed with the entire alphabet on the back of his right hand.

A bone bobbin with glass beads, known as spangles, inscribed with the name 'John Wood', post 1850. This bobbin is attributed to English bobbin maker David Haskins. Bobbins were used to hold thread for lacemaking and were popular gifts and keepsakes. They bear the same kind of inscriptions that can be found in tattoo descriptions. Several convicts named John Wood were transported to Australia, and it is possible that the bobbin commemorates the John Wood who arrived in Western Australia in 1864.

When William Johnson was charged with 'stealing a gown' he gave his age as fifteen, but according to court proceedings he was just twelve. Tattooed on the inside of his left arm was a woman and the initials 'J.J.'. The inside of his right arm was tattooed with a 'heart & darts' and the initials 'F.J.J.J.'. Johnson's tattoos could have referred to his sister, Frances, and his brother, Joseph. The 'F.J.' and woman might have represented his mother, who was also named Frances. If so, it may not have been of reminder of maternal love but of betrayal. The gown that Johnson stole belonged to his mother and it was she who prosecuted him, damning him to seven years in Van Diemen's Land.

POLICE No. *882* 18*35*

DESCRIPTION OF *William Johnson 7 years*

Transported for Robbing my Mother of a Gown,
she prosecuted me, flogged at the Hulk for talking in the Chapel

Trade *boy*

Height (without shoes) ... *4/11*

Age *15*

Complexion *fresh-*

Head.................

Hair *lt. bro*

Whiskers

Visage...............

Forehead............

Eyebrows

Eyes *Grey*

Nose

Mouth

Chin

Remarks

Woman inside left arm
J.J. heart & darts F.J.J.J. inside rt. Arm

MASONIC ARMS

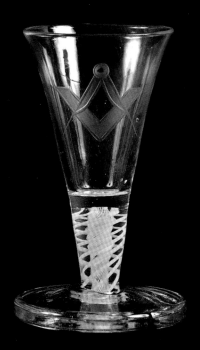

A Georgian glass with opaque twist stem, bearing Masonic Arms. Glassware was decorated with many of the motifs of convict tattoos, such as flowers, ships, flags and names.

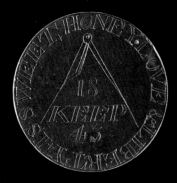

A love token inscribed with a compass straddling '18 KEEP 43', and 'LOVE & LIBERTY + IS SWEET + HONEY'. The numbers may commemorate the year 1843 or the ages of a couple whose names are engraved on the opposite side. 'Keep' is an abbreviation of 'keep within compass', a motto advocating prudence and harmony.

The Freemasons were a secret fraternal society primarily concerned with morality and spirituality. Masonic symbolism was based on the stonemason craft of its founding fathers. Members acknowledged one another with coded signs and gestures, but for Freemasons transported to Australia, the opportunity to engage with other members may never have presented itself. Allegiance may have been more easily conveyed via a tattoo. William Brown was tattooed with 'Masonic arms'—a framing square and compass. The image can represent God, the architect of man, and the ideal of squaring one's action within a moral compass. In some cases, such as Thomas Mabbott's 'Square & Compass', the arms were noted in full in the convict's record. Mabbott was also tattooed with other masonic symbols including the mallet, chisel, trowel, ladder and level. The mallet reminded Masons to maintain a good disposition. The chisel represented the advantages of discipline and education; the trowel, the need for a strong unifying bond; the ladder, progress; and the level, the idea that all men are aligned in their basic needs.

Many masonic symbols, however, held a broader appeal. Women were excluded from Freemasonry, yet female convicts, such as Mary Williams and her '7 stars', are recorded as being tattooed with the symbols used by Freemasons.

Despite its secrecy, Freemasonry proved to be popular—by 1891 there were 198 Australian Freemason lodges with more than 10,000 members. At the time of first settlement, however, Freemasonry was outlawed. In 1803, Governor King forbade the first Masons to meet in the colony of New South Wales, fearing that 'every soldier and other person would have been made a Freemason, had not the most decided means been taken to prevent it'. Such a unified body was a potential political threat. The first lodge was not formed until

1820, under the administration of Governor Macquarie, himself a Freemason. But prior to this, Masons may have met at the Freemason's Arms, a pub licensed to ex-convict and Freemason James Lara. A Freemason's Arms pub predated the first lodge in Van Diemen's Land, and was licensed to another ex-convict, James Ballance.

By the 1820s, Freemasonry may have been seen as a positive influence on convicts. When Lieutenant-Governor Arthur took up office in Van Diemen's Land he implemented a notoriously strict regime, but he remained supportive of Freemasonry, despite the fact that he was not a Mason. When publican and Freemason James Ballance died no mention was made of his convict past, and he was eulogised as 'an old and highly respected inhabitant'. For some convicts being identified as Freemasons might have been a way to improve their social standing and circumstance. John McCall was tattooed with a crucifix, the words 'God save the King', a compass, and '481'—the number of a masonic lodge in England. McCall's tattoos, advocating a patriotic, spiritual and moral integrity, might have led to him being assigned to Jocelyn Bartholomew Thomas, a prominent landowner and a justice of the peace. In his capacity as justice of the peace, Thomas was tasked with keeping a register of the local Freemasonry constituent.

'KEEP WITHIN COMPASS', a late eighteenth-century print, attributed to Robert Dighton. A compass inscribed 'FEAR GOD' straddles a thriving landscape where a well-dressed man motions to sacks of guineas. The circular border contains the words: 'KEEP WITHIN COMPASS AND YOU SHALL BE SURE, TO AVOID MANY TROUBLES WHICH OTHERS ENDURE'. Four vignettes, accompanied by verse, depict gambling, prostitution, a shipwreck and convicts:

> Shun Cards & Dice if you would thrive,
> Some other Course pursue.
> For Gaming will disturb your mind,
> And waste your substance too.
>
> The Whore with all her borrow'd charms,
> More easy to deceive you.
> Will fawn & flatter make you drink,
> Next rob & then she'll leave you.
>
> Attempt according to your strength,
> Close by the Shore to keep.
> 'Tis safer than to hoist up Sails,
> And plunge into the deep.
>
> By honest and industrious means,
> You'll live a life of ease,
> Then let the Compass be your guide,
> And go where e'er you please.

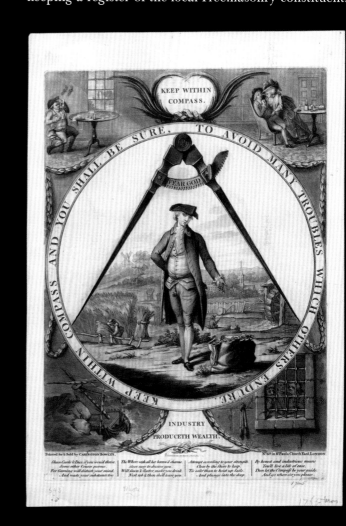

James Brown, sentenced to life for stealing twelve sovereigns from a house, was a forty-eight-year-old house servant and a widower with two young children from the Irish county of Fermanagh. Brown was also a Freemason, and he expressed his affiliation with a tattoo of a square, a compass and 'No.300', the number of a Masonic Lodge in the nearby county of Cavan. At this time, poverty in Ireland was widespread and wretched, and Brown may have been forced to readjust his 'moral compass' in order to feed his family.

After arriving in Van Diemen's Land, without his children, he absconded but was caught by convict constable George Lucas. Brown bludgeoned the constable with a 'shillelagh', an Irish walking stick with a club-shaped head, and escaped. Constable Lucas died from his injuries, and Brown was caught and sentenced to death. However, as Brown did not take the constable's musket, the authorities did not believe that he showed murderous intent and he was spared the hangman's noose. His record carries no further charges, so it would appear that, in keeping with his tattoo, Brown managed to square himself with the powers that be.

POLICE No. *1180* 18*29*

DESCRIPTION OF *James Brown Life*

Transported for stealing in a Dwellinghouse

Ho. Servt. & Groom

Trade	*Ho. Servt. & Groom*
Height (without shoes) ...	*5/4*
Age	*48*
Complexion	*dark*
Head.................	*round*
Hair	*black*
Whiskers	*black*
Visage...............	*oval*
Forehead...........	*perpendic wrinkled*
Eyebrows	*black*
Eyes	*Grey*
Nose	*long*
Mouth..............	*M. W.*
Chin	*M L.*
Remarks	

CH. Square & Compass No. 300 rt. Arm
Woman inside left arm
rings pricked on middle & little fingers left hand

MERMAID

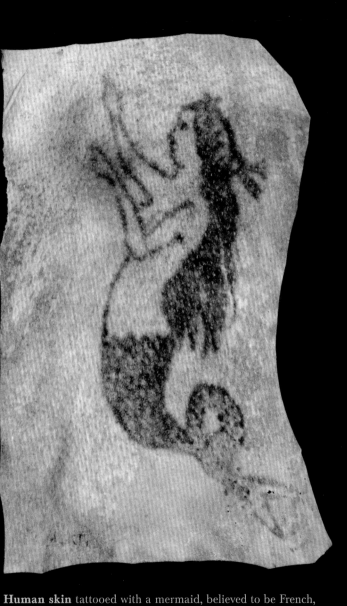

Human skin tattooed with a mermaid, believed to be French, circa 1850–1900. Mermaids were particularly popular among male convicts, who were also tattooed with mermen. Convict George Passmore bore a 'merman with lance and fish'. Reports of mermaid sightings persisted well into the late nineteenth century, and many people believed them to be real. In 1838, a mermaid caught in Sydney Harbour was displayed in Sydney. It was soon exposed as a hoax.

Mermaids were celebrated for their beauty and melodious voices, but feared for their habit of luring sailors to watery graves. As a symbol of desire, duplicity and duality—as both human and fish—the mermaid may have been of particular significance to convicts who longed for their loved ones, felt betrayed by accomplices or misjudged by authority. Approximately four per cent of tattooed male convicts bore images of mermaids.

During the Middle Ages the mermaid was appropriated by the Christian church as a symbol of damnation and used to caution against lust, vanity and temptation. For this reason, mermaids adorned places of worship. At Westminster Abbey in London, a mermaid carved from oak clutches a mirror and combs her hair. The mirror and comb symbolise the sin of pride. William Worrell was tattooed with a 'mermaid & comb' but Worrell may not have been advertising his moral shortcomings—rather, his mermaid might have been chosen for her aesthetic appeal. In 1840, at least thirty-one men were tattooed with mermaids while sailing to Van Diemen's Land aboard the *Lord Lyndoch*.

Some convicts bore tattoos of mermaids with fish. Fish symbolise Christians, Christian souls and also Christ. In Christian art, a fish gripped by a mermaid depicts a lost soul, one claimed by the netherworld. John King was tattooed with a mermaid 'with flag in hand and fish the other'. George Barker bore a 'mermaid spearing two fish'. Thomas Smith had a 'mermaid holding a fish part of man', though the man noted in Smith's record probably wasn't a disembodied sailor or a divorced soul but an incomplete tattoo positioned next to his mermaid.

Despite a long-standing association with mortality and immorality, mermaids have managed to strike a less portentous note. Examples can be seen in heraldic

representation and in commercial promotion. In the sixteenth century, a fraternity of literary notables known as the 'Sireniacal Gentlemen', frequented the Mermaid Tavern in London. Members reportedly included Sir Walter Raleigh and William Shakespeare. For them, the mermaid moniker may have conveyed a sense of their captivating conversation, but it's also possible that it reflected their bawdy behaviour and reckless abandon. The *Mermaid* was also the name of a transport ship that dispatched convicts to Australian shores over more than twenty years.

In British folklore, mermaids were capable of good deeds, such as saving people from drowning. A mermaid tattoo may have been worn as a talisman of good fortune, expressing hope for a safe journey or reunion. According to nineteenth-century criminologist Cesare Lombroso, a mermaid tattoo symbolised a sea voyage. Francis Pouten, a convicted fisherman, was tattooed with a man, a woman, his initials, those of a loved one and a 'Mermaid Ship Anchor'. Edward Bell's mermaid was tattooed next to a string of initials that included his mother and brother.

Other aquatic tattoos include Neptune, the Roman God of the sea, who symbolised strength and fortitude. Seahorses, which have similar traits, were often depicted towing Neptune in his throne. William Frampton, a 'great villain', was tattooed with a seahorse and Neptune. Despite his long criminal career, he did commit an act worthy of his mascots. In 1842, he was commended for saving the life of a drowning man.

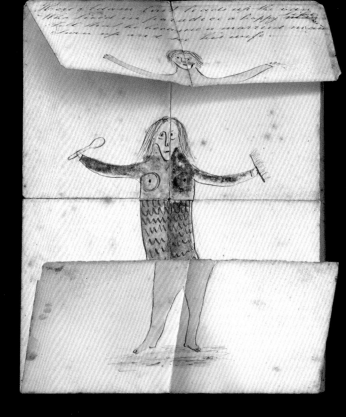

A flip-out book, dated 1837. The book begins with a picture of Adam and a poem that instructs the reader to fold up the upper flap bearing Adam's head and torso. Eve is revealed along with a second rhyme urging the reader to unfold the lower flap featuring Eve's legs. The image of a mermaid, clutching a mirror and comb, completes the sequence. The final verse reads:

A mermaid voice is sharp &nd shrill
as other women be
but if you cross them in their will
you'l anger tow or three.

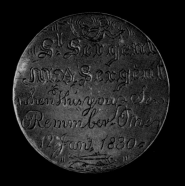

A love token bearing a trident-toting mermaid, a fish, and the words 'S l Sergent M A Sergent when This you Sea Remember Me 12 Jany 1830'. The token is attributed to Samuel Sergeant, who was transported to Van Diemen's Land in 1830.

Ann Gough was sentenced to seven years' transportation for 'stealing from the person', a crime defined as robbery with intent. Gough was tattooed with initials, a mermaid, an anchor, a heart and stars. On her arrival in Van Diemen's Land, she admitted to having spent the previous five years 'on the town', nineteenth-century parlance for being a prostitute. Perhaps, in keeping with the mermaid tattooed on her left arm, Gough used her dark eyes, auburn hair and 'fresh' complexion to seduce her mark in order to steal his money. Prostitution was a common means of supporting oneself in nineteenth-century Britain and practised by an estimated one in three female convicts. Prostitution was also prevalent in Australia. It was the last offence recorded on Gough's record before she was granted her freedom in 1842.

DESCRIPTION OF *Ann Gough 7 years*

Transported for Stealing Money from the person

Trade *house servant*

Height (without shoes) ... *4/11*

Age *20*

Complexion *fresh*

Head.................. *long, large*

Hair *Red brown*

Whiskers *-*

Visage.................. *large, oval -*

Forehead............. *High*

Eyebrows *Dk brown-*

Eyes *Dk brown-*

Nose *M.L*

Mouth.................. *M.W*

Chin *M.L*

Remarks

pockpitted - Stout made.

E.E.R.R.M.S.P.C.L.R.G.M.G.E.M.

Mermaid & Anchor on left arm.

W.G.G.S.D.M.J. heart L.M.

2 Stars. M.L.H. on rt. arm

PUGILIST

A ceramic Staffordshire figure of pugilist Tom Cribb, circa 1815. Spode, one of the more prominent Staffordshire potteries in England, was founded by Josiah Spode in 1770. His grandson, Josiah Spode the Third, briefly managed the business before relocating to Van Diemen's Land in 1821. In 1827, he was appointed muster master in the convict department, where he was tasked with recording convict tattoos, many of which he would have recognised as imagery printed on the family pottery.

Boxers, or pugilists, had celebrity status during the nineteenth century. They were immortalised in various visual arts, as well as in tattoos. William Shapton was tattooed with four pugilists and the initials 'J.W. S.B. T.C. T.S.', probably abbreviations of champions Jem Ward, Simon Byrne, Tom Cribb and Tom Spring. James Tansey was tattooed with pugilists and the letters 'H. & M.', a likely nod to the English championship of 1788, between Richard Humphries and Daniel Mendoza. John Beautiman's right arm was tattooed with a pugilist and his own initials.

A pugilist tattoo may have been a form of intimidation, a warning that the bearer was not to be trifled with. It is possible that convicts touting boxing tattoos were partial to a bit of biffo. Of forty-two convicts identified with a boxing motif, nine were punished for fighting. Some, like Frederick Elly, who was scarred on his nose and upper lip, appear to have had injuries as testament. Transported pugilists, however, do not appear to have been partial to pugilist tattoos. At least twenty boxers were transported to Australia. William Looney, a Liverpudlian, was untattooed but was scarred across his left hand. Samuel Belasco, brother to celebrated pugilist Abraham Belasco, had not inked his limbs, but was less prudent when it came to blackening his fists. For 'fighting a pitched battle' (an organised fight) Belasco copped forty lashes. Boxing matches were illegal and pugilists risked punishment. Those that did partake in a punch-up also risked their lives: in April 1842, convict Charles Evens died following a forty-five-minute bout at the Jerusalem Probation Station in Van Diemen's Land.

Other outlawed colonial bloodsports included dog fighting, cockfighting and bull baiting (the act of setting savage dogs on a bull). George Lee was tattooed with 'bull bait and two dogs' and James Mellow with

'2 cocks fighting'. William Frost, a jockey and groom, was tattooed with three pugilists on his right arm and a racehorse and jockey on his left, the latter possibly depicting himself or his brother John, a professional racer. Images of action could be tattooed on the upper arm, allowing them to be animated by flexing and relaxing the bicep.

Women were less inclined to be tattooed with sporting imagery. And some men were drawn to less violent forms of recreation. George Davies was tattooed with a 'heart spade club diamond', although coming by a pack of playing cards was no easy thing: John Glanville was flogged for fashioning a pack from a Bible. John Perry was tattooed with a 'dicebox'. Dice were easier to come by: they were carved from old dinner bones. John Wilson forwent fighters, dice, dogs, cocks and cards, and was tattooed with the simple yet swaggering sentiment 'I won'.

A newsclipping of John Perry. Perry, known as 'Perry the Black' was an Irish pugilist born in 1819. In 1846, he was convicted of passing forged notes and sentenced to seven years' transportation. Perry claimed he was innocent, and it has been suggested that rival pugilist Tom Spring stitched him up. In 1849, Perry fought George Hough for the Australian championship and won. But, after repeated run-ins with the law, he died a drunken and penniless drifter in 1867.

Thomas Good, a 'very bad character', was transported for life for stealing a hat. Like the pugnacious pugilist pricked on his left arm, Good proved to be something of a hard case. Prior convictions not withstanding, his Van Diemonian record boasts twenty separate offences including 'assaulting and abusing his master and threatening his life in a most violent manner', 'striking his overseer', 'fighting in the shoemaker's shop' and 'assaulting a prisoner'. In 1846, Good received a conditional pardon, and, like his last name and not his battler tattoo, he remained 'good'.

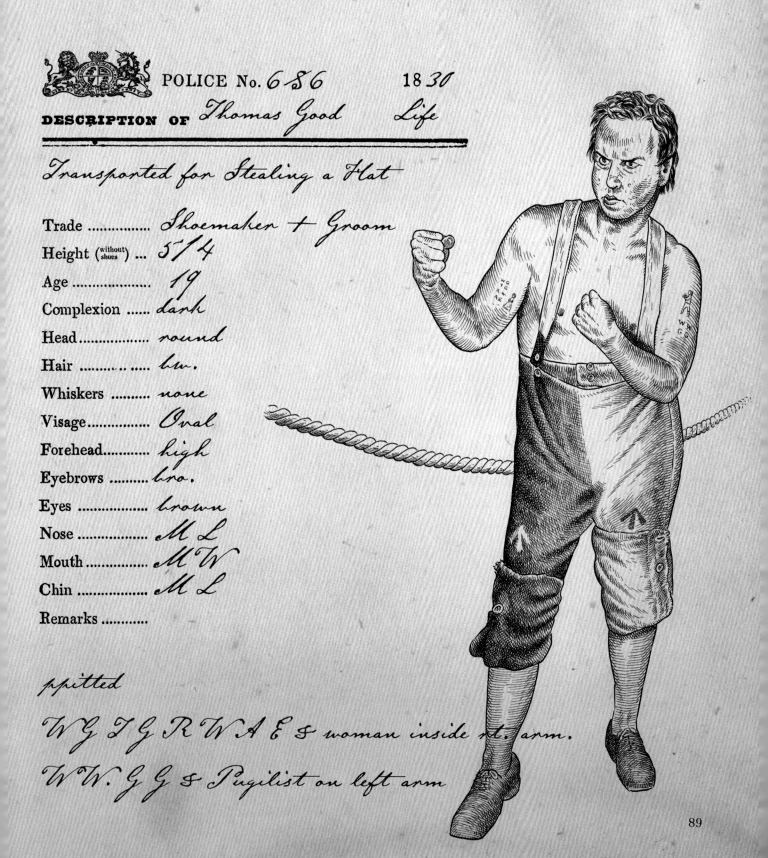

POLICE No. 686 18 30

DESCRIPTION OF *Thomas Good Life*

Transported for Stealing a Hat

Trade *Shoemaker + Groom*
Height (without shoes) ... *5/4*
Age *19*
Complexion *dark*
Head *round*
Hair *bro.*
Whiskers *none*
Visage *Oval*
Forehead *high*
Eyebrows *bro.*
Eyes *brown*
Nose *M L*
Mouth *M W*
Chin *M L*
Remarks

ppitted

W G T G R W A E & woman inside rt. arm.

W. W. G G & Pugilist on left arm

89

RING

A ring symbolises eternal devotion: it has no beginning and no end. Rings have endured as matrimonial symbols for centuries. Convicts were not permitted to wear finery in any form; precious items like wedding rings may have been entrusted to the loved ones they left behind. Those that did arrive with jewellery were obliged to leave it with the authorities until they gained their freedom. Tattooed jewellery, however, was not removable and rings and bracelets account for some five per cent of male convict tattoos.

A wedding ring was traditionally worn on the left hand, which symbolised dependence and subjection (the right hand, independence and authority). The fourth finger was the favoured digit as it was believed to carry a vein that led directly to the heart. When documenting rings in a convicts' records, clerks frequently wrote 'ring pricked'. Some convicts were recorded as bearing simply a 'ring' and may have been wearing an actual wedding band that was unable to be removed. John Hughes was described as bearing 'a finger ring on ring finger'.

In later years the authorities may have relaxed the rules a little. William Sweet's record states 'wears earrings' and James Hicks apparently wore a wig. Thomas Baggett had a ring on his left ring finger, which was almost certainly a tattoo and a reminder of his wife, Mary. Their union may also have been reflected in the 'man woman M.B.T.B.' tattooed on Baggett's left arm. Despite this, Baggett declared to the authorities that he was single.

Not every convict tattooed with a ring was, or admitted to being, married. Some ring bearers may have wanted to start over, while others might have carried betrothment or friendship rings. Martha Evison claimed to be single but bore a 'ring mark' on her left middle finger, which may have been the blemish left by a wedding ring. Another self-proclaimed single woman,

Eliza Roberts, who hailed from Middlesex, had a 'ring on ring finger' that may have expressed her connection to John Hay whose name was tattooed on her right arm. A John Hay from Middlesex arrived in Van Diemen's Land the year after Eliza. He too declared himself a free agent yet his right arm was tattooed with a 'sailors bride'.

Married couples transported to Australia were not uncommon. Some convicts even committed crimes to be reunited with their loved ones. Catherine Moore, Alice Hallissy and Lydia Casemere all admitted to breaking the law to be reunited with their husbands. John Naylor, however, claimed to have committed his crime to be transported away from his wife. But despite any unwavering devotion, instances of convict couples bearing rings on their ring fingers are hard to come by. Of fifty married couples known to have been transported to Australia, not one was united with finger ring tattoos.

Curiously, the vast majority of ring-tattoo bearers claimed to be single despite the most common ring recorded on female convicts being the left ring finger. The most popular finger for men was the left middle finger. According to nineteenth-century Spanish author Madame Anita de Barrera, a ring worn on a man's left middle finger indicated he was engaged. John Minshew's *Polyglot Dictionary* of 1625 states: 'a ring on the thumb denoted a soldier, or doctor; on the finger next to the thumb, a sailor, or merchant; on the middle finger a fool; on the fourth or ring finger, a married or diligent person; and on the last, or little finger, a lover.' Due to the permanency of tattooed rings, a convict's changed circumstances may have left a once-symbolic ring tattoo with little significance. Seaman Matthew Sharp had rings tattooed on three fingers on his left hand and William Farrier had no need to declare his foolishness via a ring, for he had 'fool' tattooed across his forehead. Like James King, who was tattooed with rings, bracelets and a necklace, some convicts might have just been partial to a bit of ink bling.

A **gold posy ring** inscribed 'Live in Love', eighteenth century. Gold rings bearing inscriptions were termed posy rings. Posy inscriptions number in the thousands and echo sentiments tattooed on convicts. John Mason was tattooed with the words 'Love & Live Happy', and a ring on his right middle finger.

A **gold posy ring** inscribed 'MY [heart] and [eye] UNTIL I DIE', eighteenth century. The words heart and eye are presented symbolically, as they are in tattoos. Thomas Collins was tattooed with a heart on the ring finger of his left hand and a ring on his little finger.

An **enamel box**, circa 1770, decorated with rings and flowers. Enamel boxes increased in popularity in the eighteenth century. Their various decorations reflect the imagery recorded in tattoo descriptions: anchors, beehives, Britannia, doves, hearts, ships and words of sentiment.

Harriet Derbyshire, a clothes thief and 'bad character' was transported for stealing garments from her sister. Derbyshire declared herself married with three children, and it is likely that the C.D. tattooed on her arm were the initials of Charles Derbyshire, her husband. Their union may also have been the reason for the ring tattooed on her left ring finger. But despite her tattoo declarations, it seems Harriet soon forgot her husband. In 1848, colonist William Withers and Harriet Derbyshire requested permission of the lieutenant-governor to marry, a requirement of convicts under sentence. Their request was approved, provided that the clergyman was satisfied that Harriet's former husband was dead. Presumably the happy couple produced a letter boasting Charles Derbyshire's early demise, and a ring of gold was slipped over the ring of ink on Harriet's left hand. Considering that it could take longer than six months for English mail to arrive, the pair may well have been fibbing. Of seventeen female convicts identified with a ring tattooed on just their wedding ring finger in the records, sixteen applied to be married and at least twelve of those requests were approved. But for William and Harriet wedded bliss was not to be. After a drunken day at the races in 1871, William was pulled over for reckless driving. Discovered in the bottom of the cart was Harriet, with her neck snapped. William, found 'sitting upon her body' had, it seems, crushed her to death while driving around in a drunken stupor.

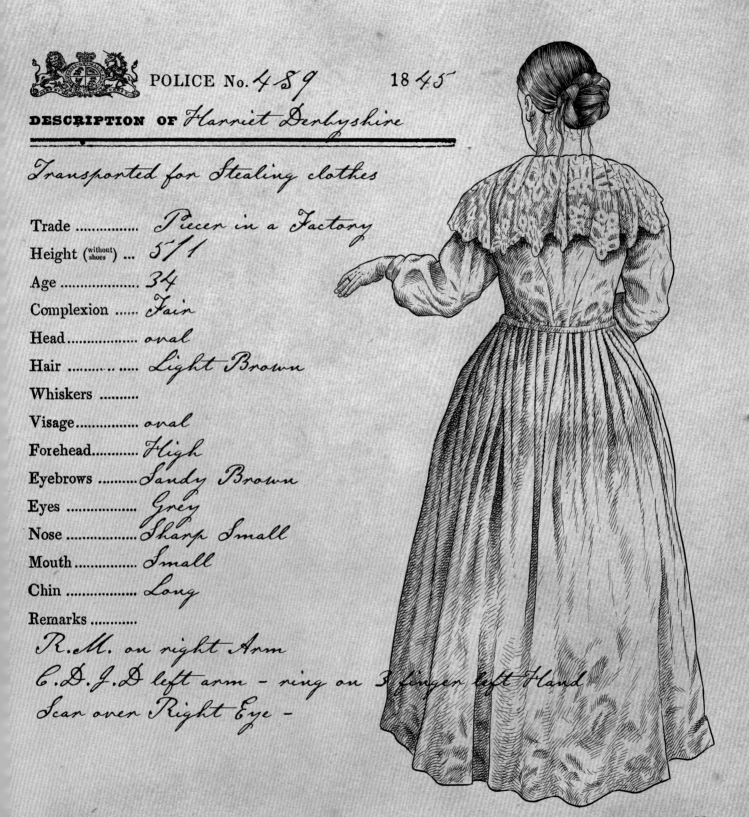

POLICE No. 489 1845

DESCRIPTION OF *Harriet Derbyshire*

Transported for Stealing clothes

Trade *Piecer in a Factory*
Height (without shoes) ... *5'1*
Age *34*
Complexion *Fair*
Head *oval*
Hair *Light Brown*
Whiskers
Visage *oval*
Forehead *High*
Eyebrows *Sandy Brown*
Eyes *Grey*
Nose *Sharp Small*
Mouth *Small*
Chin *Long*
Remarks

R.M. on right Arm
C.D.J.D left arm – ring on 3 finger left Hand
Scar over Right Eye –

SEVEN STARS

A cluster of seven stars in the constellation of Taurus, approximately four hundred light years from Earth, has captivated humans for millennia. Their names are Maia, Electra, Taygete, Alcyone, Celaeno, Sterope and Merope. In Greek mythology they are the seven daughters of Atlas. Zeus transformed the girls into stars to save them from the wanton clutches of Orion. They have since been known as the 'Seven Sisters' and the 'Pleiades'.

Monuments aligned to the constellation include the Temple of the Sun in Mexico, the Great Pyramid of Giza in Egypt and the Parthenon in Greece. The writers Byron, Homer, Milton and Plato among others were enthralled by the Pleiades. The stars also proved popular among tattooed Brits during the nineteenth century—nearly five per cent of tattooed male convicts bore a constellation, typically one containing seven stars.

The cluster was crucial in celestial navigation. Joseph Green, a navigator and a convict, was tattooed with his initials and the seven stars on his left arm. The Pleiades were also used to pinpoint the northern hemisphere vernal equinox. In ancient Rome the stars were known as Virgilio; the Virgins of Spring. The poet Virgil celebrated the arrival of spring with reference to Taurus in the lines: *Candidus auratis aperit cum Cornibus annum taurus*, 'when the bright bull with gilded horns opens the year'. A convicted ploughman by the name of William Woods may have alluded to the transition in the 'roman man & 7 stars' tattooed on his right arm. Alternatively, Woods' tattoo could have Biblical connotations as 'seven stars' are mentioned in the Book of Revelation and the Pleiades in Amos and Job. The cluster also features in sixteenth-century literature dealing with occult philosophy and Freemasonry. Michael Kenny, thought to be a Freemason, was tattooed with a 'Ladder Half Moon & 7 Stars' on his inner left arm, perhaps symbolising his spiritual progress. In Freemasonry the Pleiades can represent immortality, the seven masons required to start a lodge and the seven liberal arts: grammar, dialectic, rhetoric, arithmetic, geometry, astronomy and music. However, Masons may

An 1830s love token inscribed with the initials 'W H', two doves clutching a sprig, two hearts pierced with darts and a crown. Other symbols are Masonic: the eye of providence, a ladder, a level, a trowel, a square and compass, and the sun, moon and seven stars.

A love token, dated 1832. A man chained at the wrists, ankles and waist, stands surrounded by flowers, thistles, a crescent moon and seven stars. The token is inscribed 'Charles Vale' and could pertain to a Charles Vale who was transported to Van Diemen's Land in 1838 for burglary.

have kept the Pleiades' original significance a secret, and their true Masonic meaning may never be known—one nineteenth-century author wrote: 'to tell ears profane, what this emblem means, would be disclosing the sacred arcana'. As Freemasonry increased in popularity the Pleiades began to be widely seen on everyday items, such as tableware. In most instances, including in tattoo descriptions, they occurred as a constellation with a crescent moon and a blazing sun.

In Christianity and general tattoo lore, constellations can represent Christ, God, heaven, angels, life, death, eternity, illumination, navigation, guidance and protection. Convicted housemaid Elizabeth Spragg was tattooed with 'Sarah Spragg my dear Mother 7 stars' and 'Joseph Sprague my dear 7 stars'. Among the many tattoos adorning seaman John Smith were 'sun 7 stars ½ moon Crucifixion Star' on his left arm and 'Sun, 12 stars ½ moon' on his right arm. The '12 stars' possibly symbolised the Twelve Apostles.

For many convicts the Pleiades probably symbolised their homeland. For those transported to Australia, a tattoo of the Pleiades may have been particularly poignant: in the southern night sky the cluster would have appeared to be upside down and, like the convicts themselves, to have taken a turn for the worse.

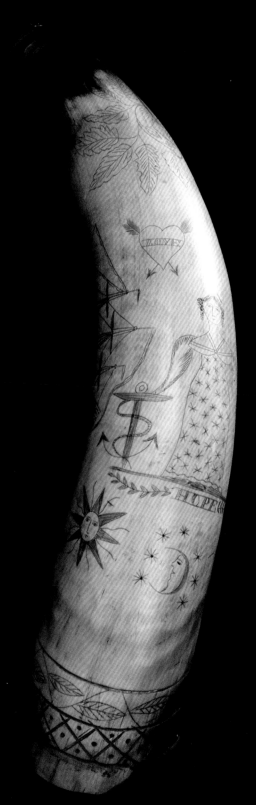

A gunpowder horn, circa 1800–50. Carved into the horn are leaves emanating from a flowerpot, a heart pierced with darts and bearing the word 'LOVE', a ship and the virtue of hope clutching an anchor above laurel sprigs and the word 'HOPE'. The sun, moon and seven stars feature below. A bracelet of leaves, dots and diamonds runs around the base.

George Neal was done for burglary and transported to Van Diemen's Land for ten years. He was tattooed on his arms with the names of loved ones and various images including a sailor, a woman and a flowerpot. Within a few weeks of landing, Neal was charged with misconduct and sent to languish in a cell for almost a week. Time in solitary was something that Neal would have to get used to. During the course of his criminal career he did more than three hundred days in solitary confinement and about two years in 'separate treatment' at Port Arthur's Separate Prison, a slammer specifically built to isolate convicts. Inmates spent nearly twenty-four hours a day confined to a cell, and when they were let out they were forbidden to speak and were made to wear hooded masks to prevent any communication. If that wasn't bad enough, troublemakers could wind up in pitch-black refractory cells. Neal did several stints in the dark cells, as they were known, but perhaps the diminutive ex-chimney sweep with his pallid skin and hardened mind was impervious to blackened hellholes and, like the seven stars tattooed on his left arm, he continued to shine.

DESCRIPTION OF *George Neal 10 Years*

Transported for Burglary

Trade *Sweep*
Height (without shoes) ... *5/1*
Age *19*
Complexion *Sallow*
Head.................. *round*
Hair *Lt Brown*
Whiskers *None*
Visage................ *Oval*
Forehead........... *Large*
Eyebrows *Black*
Eyes *Hazel*
Nose *Large*
Mouth.............. *Medium*
Chin *Medium*
Remarks

Woman. E Carrall. Moon. Burn on Rt Arm
Sailor. half moon – 7 Stars – J x N – B x S x C
Flower pot – Anchor – Heart + Dart do – do –
Crucifix on left Arm – Scar on Breast

SHIP

A love token, dated 1838. A convict in chains stands on the shore, beneath birds and the sun, moon and seven stars. In the background his ship departs. Written on a rock is 'Wm Brain'. The token is attributed to William Brain, transported to New South Wales in 1839 for housebreaking.

A transfer-printed, rolling pin, post 1860. Glass rolling pins were typically filled with salt, tea, spice or liquor and kept hanging in the kitchen. The words 'LOVE AND BE HAPPY' are flanked with the Great Australia, a clipper launched in 1859, and a verse. Convicts James Baxter and John Popjoy were tattooed with an abridged version of the verse:

> From rocks and sands and barren lands
> Kind fortune keep me free,
> And from great guns and woman's tongues
> Good Lord deliver me.

Approximately one per cent of tattooed male convicts bore a tattoo of a vessel of some kind: brigs, boats, cutters, sloops, ships and fishing smack. Some of the more unusual descriptions in the records include 'keel of a ship', 'figure of hulk', 'hull of a ship', 'Noah's Ark' and 'man in whaleboat throwing harpoon'. A ship typically symbolised travel, distance and separation. William Lunt was tattooed with a heart, ship, wreath, initials and 1838, the year he was transported. Mary Medlicot had two ships, the initials 'B.M', an anchor and the words 'the land of sorrows'. Her mother, Bridget, was also transported, and Mary's tattoos could be read as: 'Bridget and Mary hope to be together in Van Diemen's Land'.

A ship can also symbolise a church: a place of refuge and salvation. The third-century Roman theologian Hippolytus wrote: 'The world is a sea in which the Church, like a ship, is beaten by the waves, but not submerged.' The word nave, the central space of a church, comes from the Latin *navis*, meaning ship. And a ship's mast, like an anchor, symbolises the cross. Daniel Hammett was tattooed with 'God direct me for the best', his initials and a brig.

Some convicts were tattooed with particular ships. Seaman Charles Deverall was tattooed with a brig labelled *Badger*, the first command of Vice Admiral Lord

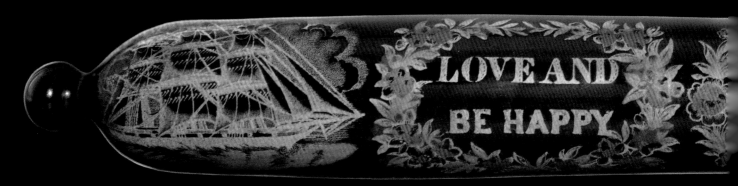

Nelson. Henry Orme, transported aboard the *Moffatt*, was tattooed with a ship labelled *Moffat*. Joseph Sutcliff, transported aboard the *Prince Regent*, was tattooed with a 'bust of the Prince Regent', which may have depicted the ship's figurehead, a rendering of King George IV.

Convicts were also tattooed with the 'sailor's farewell': a scene of a sailor between his family and ship. The scene may have originated in 'The Sailor's Farewell', a ballad written by Captain Edward Thompson in 1765. William Thompson, another seaman turned highwayman, was tattooed with the lines:

> Farewell Dear Wife Shed no more tears
> for I must Cross the Sea for several years
> when I return back from the Main I hope to live Happy.

Near this tattoo was a cutter, an anchor, a mermaid, a crucifix, a man, another anchor, a woman, Thompson's name and the name of his wife, Catherine. On his chest was a brig and an anchor; on his right arm a sailor, a woman, an anchor, the words 'Happy Return', a flowerpot, two hearts, his initials and those of his wife and four daughters. John Welsh, however, went without tattoos representing his family in favour of a sailor, a dog and a house.

Variations on sailor tattoos include sailors with swords, hats, flags, mugs, bottles, pipes and cannons. These motifs were also depicted without sailors. Robert Robertson's right arm was tattooed with flags, swords, a sloop and the word 'revenge'. On his left arm and hand was a boat, the names of faraway lands and the line 'heave your ship too or else we will sink you'. The ex-farmhand had probably served in the Royal Navy, but it is possible his sea experience was as a pirate after escaping from his prison hulk in Bermuda. Robertson was, however, better known as a highwayman and a terror of the highways, rather than of the high seas.

A transfer-printed lustre mug featuring the 'sailor's farewell', circa 1820. A sailor with hand on heart bids farewell to his weeping wife and children. To his right is his cottage and to his left his ship prepares to depart.

SAILORS FAREWELL
Sweet. oh: Sweet is that Sensation,
Where two hearts in union meet;
But the pain of Separation,
Mingles bitter with the Sweet.

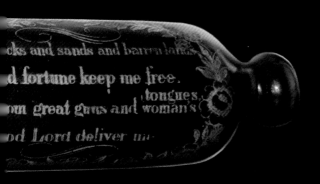

cks and sands and barr..
d fortune keep me free.
tongues
on great guns and woman's
od Lord deliver m..

SAILORS FAREWELL.
Sweet. oh: Sweet is that Sensation,
Where two hearts in union meet;
But the pain of Separation,
Mingles bitter with the Sweet.

Tom Morgan, a mariner, was tattooed with imagery reflecting his time spent in the service of his country: the figure of Britannia, a brig, the Scottish thistle and the English rose. Morgan was transported to New South Wales, then to Van Diemen's Land and then to the infamous penal station on Sarah Island. During the voyage to Sarah Island, convicts seized the ship, but Morgan refused to join them. When he was marooned in midwinter with other crew members and women and children, he set about building a rescue raft. With two penknives, a razor and twine, Morgan fashioned a frame from wattle tree. He shrouded it in hammock canvas and sealed it with boiled soap and wax. Accompanied by another ex-sailor John Popjoy, Morgan paddled for two days and two nights before encountering a ship and sounding the alarm. In the light of his gallantry, Morgan's Sarah Island term was quashed and he was assigned to the colonial fleet. The brig tattooed on his right arm perhaps served as a badge of honour and a testament to his remarkable seamanship.

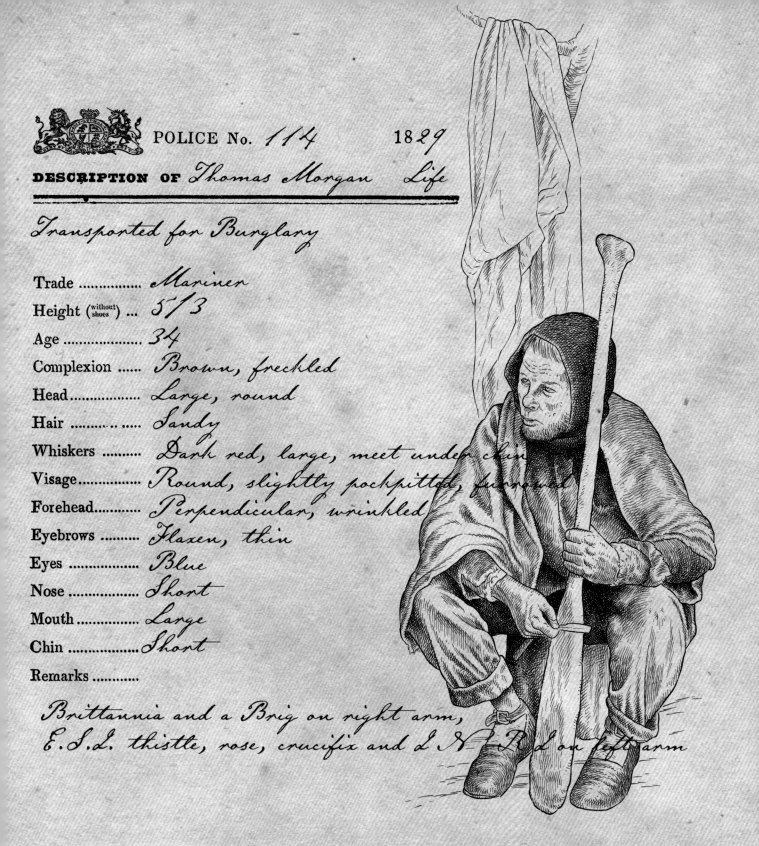

POLICE No. *114* 18*29*

DESCRIPTION OF *Thomas Morgan Life*

Transported for Burglary

Trade *Mariner*
Height (without shoes) ... *5/3*
Age *34*
Complexion *Brown, freckled*
Head.................. *Large, round*
Hair *Sandy*
Whiskers *Dark red, large, meet under chin*
Visage.............. *Round, slightly pockpitted, furrowed*
Forehead............ *Perpendicular, wrinkled*
Eyebrows *Flaxen, thin*
Eyes *Blue*
Nose *Short*
Mouth............... *Large*
Chin *Short*
Remarks

Brittannia and a Brig on right arm,
E.S.L. thistle, rose, crucifix and L N R d on left arm

SKULL AND CROSSBONES

The human skull is an age-old symbol of death and mortality. Skull symbolism came to prominence during the fifteenth century through a movement known as *Danse Macabre*, 'the dance of death', which celebrated parity in death. By the sixteenth century, skulls were an established fixture in cemeteries and churches. Bones, due to their marrow, also symbolise life force and vitality. When crossed, 'in saltire', they can express power, defiance and danger. The skull and crossbones, termed a Jolly Roger, was a popular emblem used by pirates. John Hatton was tattooed with a 'head and marrow bones', two pistols, two flags, two cannons and two axes, presumably all arranged in saltire. According to his record, Hatton was not a steely buccaneer but an impeccably behaved hairdresser. The 17th Lancers, a British cavalry unit, and reformists including chartists also adopted the skull as an insignia. But convicted pirates, lancers and chartists are not recorded as having skull-and-bones tattoos.

Some crossbones tattoos included a 'deaths head', 'head' and even 'man's face'. Those with a 'skull' were more likely to precede it with a crucifix, a symbol of eternal life and Jesus' death at Golgotha, the 'place of the skull'. Charles Parson's record states that he was tattooed with 'M.A.P. Died Oct. 11 1821 2 Flags Death & Glory marrow bones Anchor heart I.L. heart Darts'. Parsons, a widower, may have been eulogising his wife, as the term 'death and glory' was often applied to the departed bound for heaven. Thomas Smith's traditional love tattoos were coupled with a 'Woman in a coffin'. Thomas Leather was tattooed with a 'gibbet woman' and Jonathon Dale a 'gibbet with a woman hanging'. A gibbet was a structure from which the dead were hung post execution. Among Isaac Comer's tattoos was a 'man hanging from gallows'. Some convicts, Joseph Holley and William Sullivan, for example, combined skulls and bones with their own names. Termed *Memento Mori*, 'remember that you must die', mortality symbolism came to prominence in the seventeenth century. The weeping willow, symbolising grief and eternal life because of its shape and hardiness, was a favourite. By the nineteenth century it surpassed the skull in popularity. When the *Moffatt* docked in Van Diemen's Land in 1834, seventeen men tattooed with willow trees disembarked. It seems unlikely that they were eulogising six comrades who perished onboard, for accompanying initials do not correspond with those of the deceased. It is more likely that among the *Moffatt* convicts was a tattooist proficient at weeping willows, and their great number was a result of the loved ones of those onboard who died in the cholera pandemic ravaging Europe at the time. Other mortality motifs include hourglasses, urns, tombs, tombstones, monuments, cherubs, angels and skeletons. William Warren was tattooed with the 'skeleton of a mermaid', a particularly lethal combination, one might conclude, of temptress and death.

A gold ribbon slide, circa 1700. The enamel skull and crossbones eulogise a loved one whose initials, A.C., are detailed in gold wire. The background consists of a true-love knot of human hair. Mourning jewellery was popular, but such motifs were seldom tattooed on widowed convicts.

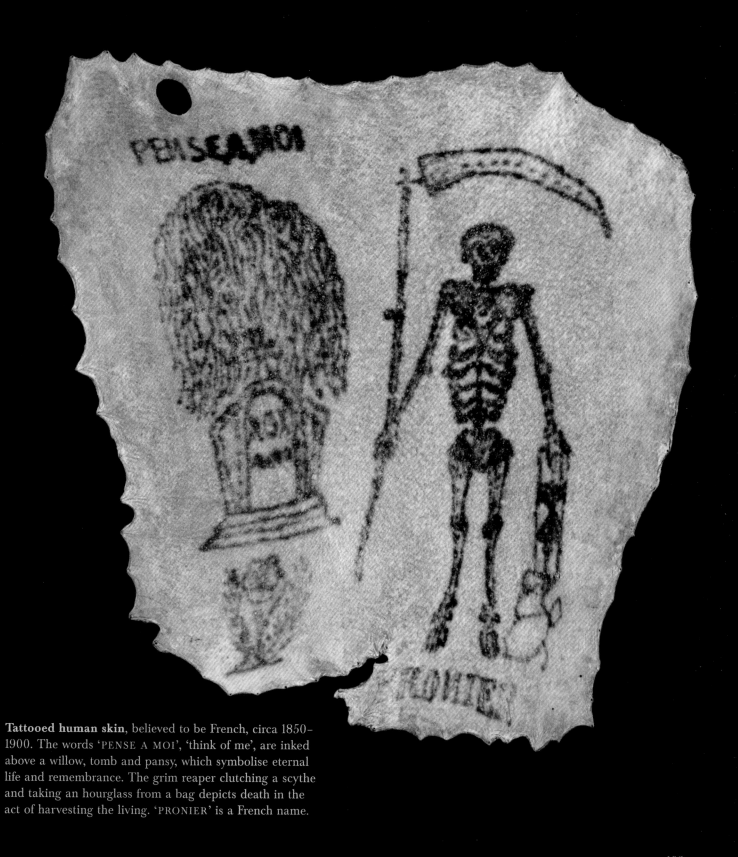

Tattooed human skin, believed to be French, circa 1850–1900. The words 'PENSE A MOI', 'think of me', are inked above a willow, tomb and pansy, which symbolise eternal life and remembrance. The grim reaper clutching a scythe and taking an hourglass from a bag depicts death in the act of harvesting the living. 'PRONIER' is a French name.

William Henry Stephens was heavily tattooed. He had more than a dozen images, including the names of loved ones, rings on his fingers, the words 'Health, Love + Liberty' and a 'head and bones'. Stephens had been gaoled twenty-one times before he was transported to Van Diemen's Land for stealing a watch. Described in his record as 'a very bad boy', he absconded six times, racked up a total of three hundred days in solitary confinement, copped more than one hundred lashes and endured nearly eight years in leg irons. Stephens also had a habit of clouting other convicts with bits of timber. His antics eventually wore down the authorities, and, in 1851, he was sentenced to death for robbing a man at gunpoint. When Stephens mounted the scaffold in the tiny town of Oatlands, he requested the hangman pull back his blindfold and in doing so, Stephens outdid his 'head and bones' tattoo by presenting the small assembly with the consummate face of death.

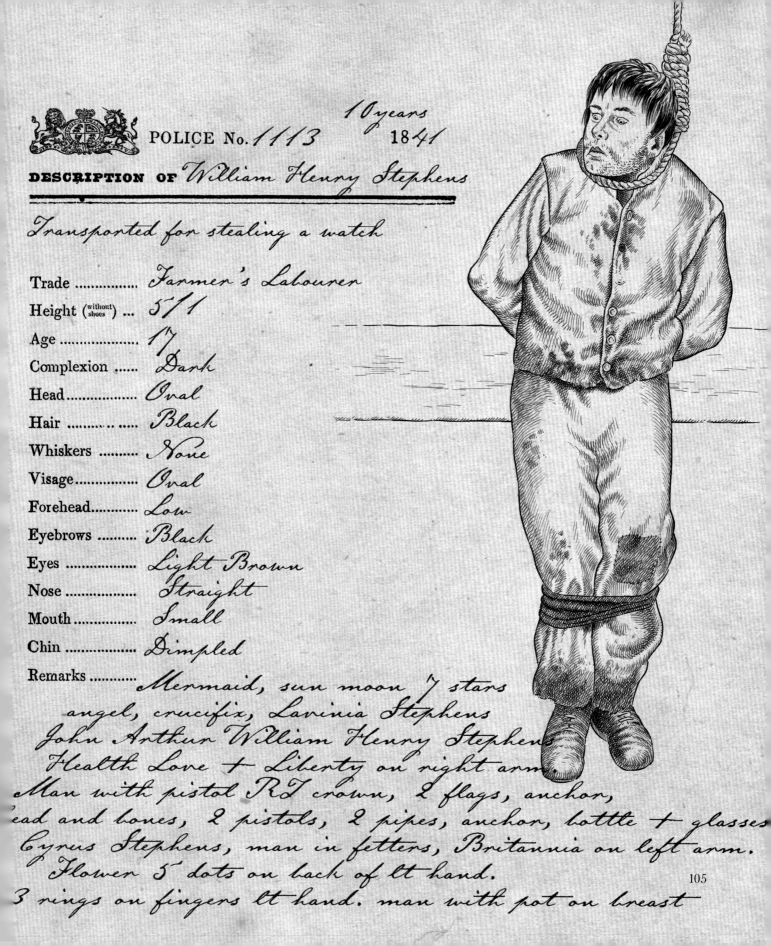

POLICE No. *1113* *10 years* *1841*

DESCRIPTION OF *William Henry Stephens*

Transported for stealing a watch

Trade *Farmer's Labourer*
Height (without shoes) ... *5/1*
Age *17*
Complexion *Dark*
Head.................. *Oval*
Hair *Black*
Whiskers *None*
Visage................ *Oval*
Forehead........... *Low*
Eyebrows *Black*
Eyes *Light Brown*
Nose *Straight*
Mouth................ *Small*
Chin *Dimpled*
Remarks *Mermaid, sun moon 7 stars*
angel, crucifix, Lavinia Stephens
John Arthur William Henry Stephens
Health Love + Liberty on right arm
Man with pistol RI crown, 2 flags, anchor,
'ead and bones, 2 pistols, 2 pipes, anchor, bottle + glasses
Cyrus Stephens, man in fetters, Britannia on left arm.
Flower 5 dots on back of lt hand.
3 rings on fingers lt hand. man with pot on breast

TRUE-LOVE KNOT

A knot is a romantic symbol of enduring devotion. The further the ends of a knot are pulled apart, the tighter the knot becomes, strengthening the bond. True-love knots were often tattooed on the inside of the upper arm, a particularly personal place.

The true-love knot gained popularity during the fourteenth century, but whether it was a particular type of knot is not clear. Seventeenth-century author Sir Thomas Browne speculated that it was the Hercules knot, also known as the reef knot. But the true-love knot might have originated in the Stafford knot. Thomas Crofton Croker, an Irish antiquary, wrote:

> There was a meaning in the single tie, or Staffordshire knot, of an entanglement of the affections, or a declaration of love; which, when the betrothment took place between the two parties mainly concerned, became doubled for the vow of faithfulness; when no cohabitation followed, the tassels or ends of the knots were set apart; but when cohabitation before marriage occurred, the tassels were brought together, and the knot issued from the form of a heart. And subsequent to marriage, if the device of a true-lover's knot was continued, the tassels became united after forming a triple tie. This triple tie, we are told, was the ordinary symbol among the northern nations of love, faith and friendship.

Croker's account is supported by the eighteenth-century English poet John Gay, who penned the lines: 'three times a true-love-knot I tie, Firm be the knot secure, Firm may his love endure.'

The Stafford knot is the symbol of, among other things, the county of Staffordshire and the town of Stafford. But its origins are unknown as the knot itself dates back hundreds of years. One legend has it that the knot's three distinctive loops were devised to form a triple noose to hang three criminals simultaneously. For besotted Brits separated by circumstance, a true-love knot made for a poignant tattoo, and it is likely that various knots were depicted, including a simple bow knot. The inside of John Woodason's right arm was tattooed with a 'true love knot & heart in centre'. Smitten seaman James Partridge was tattooed with a 'lovers knot' and would have been well versed in tying love knots as they were also put to practical use at sea. Also known as the 'pitcher knot', the true-love knot was used to hoist pitchers and buckets of water onboard.

Some seamen observed the custom of presenting their sweetheart with a true-love knot enclosed in a love letter. If the knot was returned with the ends tied together they could rest easy knowing their love was reciprocated.

True-love knot bearers were not necessarily prone to wedlock. Of the ten convicts bearing true-love knot tattoos found in the records, only two were known to be married. Joseph Hadley was tattooed with two true-love knots. One was situated with a heart, woman and the initials E. L., which are likely to have been those of his wife, Elizabeth. His other knot, however, was positioned with a heart and darts and the initials of unknown identity. But Hadley may not have been stringing anyone along, as the saying goes, for a true-love knot could also be a sign of friendship.

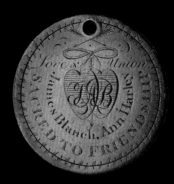

A love token inscribed with crossed arrows, a true-love knot, the words 'Love & Union', conjoined hearts pierced with an arrow and the initials 'JAB'. Encircled in a wreath are the words 'James Blanch, Ann Harley SACRED TO FRIENDSHIP'.

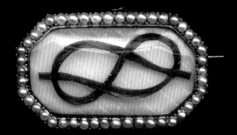

A brooch with a true-love knot of human hair bordered in gold and seed pearls on an opaline backing, circa 1820.

80th Regiment of Foot tunic button, featuring the Stafford knot above the regiment's number, surmounted by the royal crown and enclosed in a laurel wreath. The 80th Regiment served in Australia from 1837 until 1844. Ex-soldier William Brownlow was tattooed with a 'Staffordshire knot'.

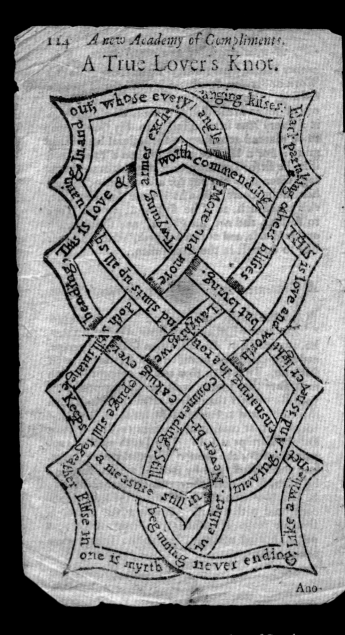

A True Lover's Knot from *A New Academy of Compliments*, eighteenth century. 'THIS is love and worth commending, Still beginning never ending. Like a wilie net ensnaring. In a round shuts up all squaring. In and out, whose every angle More and more doth still intangle. Keeps a measure still in moving: And is never light but loving. Twyining armes exchanging kifses: Each partaking others blifses Laughing we epinge still together Blifse in one is myrth in either Never breaking ever bending, This is love & worth commending.'

107

Daniel Brown was tattooed with a 'True Love Knot' on the inside of his right arm. Brown, a ribbon weaver from the English city of Coventry, was, rather aptly, deemed to have 'bad connexions'. Ribbon weavers made ribbon for clothing and footwear, and Coventry was one of the biggest suppliers. With his mate Henry Benton and fellow ribbon weaver William Perkins, Brown pilfered silk from a warehouse. The three boys were caught and sentenced to life in Van Diemen's Land. It appears the trio bonded over their plight as they each had a true-love knot tattoo. Their tattoos almost certainly symbolised their friendship, and do not pertain to other people, as the boys were not recorded as married and not one other convict onboard their transport ship was tattooed with a true-love knot, not even Brown's younger brother. In 1834, Brown was inducted into the Field Police, but for inciting convicts to abscond he was clapped in chains and sent to Port Arthur to undergo the 'severest discipline the settlement affords'. In 1841, Brown received a conditional pardon and was released from the bonds of servitude.

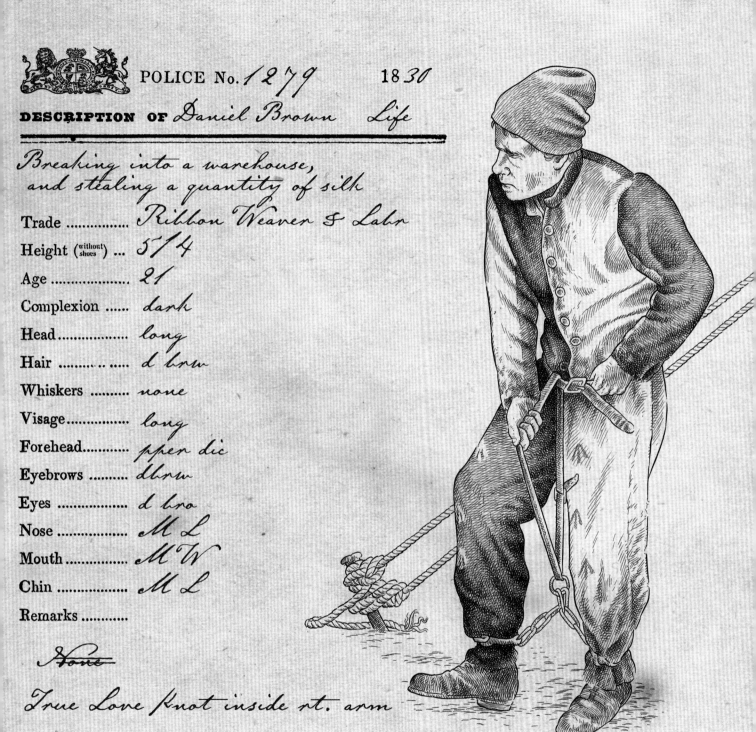

POLICE No. *1279* 18*30*

DESCRIPTION OF *Daniel Brown* *Life*

Breaking into a warehouse,
 and stealing a quantity of silk

Trade *Ribbon Weaver & Labr*

Height (without shoes) ... *5/4*

Age *21*

Complexion *dark*

Head *long*

Hair *d brw*

Whiskers *none*

Visage *long*

Forehead *pper dic*

Eyebrows *d brw*

Eyes *d bro*

Nose *M L*

Mouth *M W*

Chin *M L*

Remarks

~~*None*~~

True Love Knot inside rt. arm

'WHEN THIS YOU SEE'

Dear Parents
when this you see
remember me
And bear me in your mind
When I am far in a Foreign Clime.

A watercolour of Private Henry Watts, King's Own Royal Regiment, circa 1831. To Watts' right is a fortified garrison flying the British ensign, to his left a ship. The painting is attributed to an ex-soldier and limner named Charles Dean and was probably presented to Watts' parents before he sailed to New South Wales. 'Limners' were artists who lacked formal training and specialised in producing affordable commissions. It is possible that some limners were also tattooists.

In 1837, Sarah Welch was arrested when she fled a London silk merchants clutching sixty-eight yards of lace. When she was searched by police, a lock of hair wrapped in perfumed paper was discovered tucked between her breasts. Around her neck was a silk ribbon from which a love token dangled. It read:

> When this you see
> Remember me
> Till your true love gains
> His liberty
>
> W.N. 18th Oct. 1832

The initials almost certainly belonged to Londoner William Nest. On 18 October 1832, Nest was charged with stealing two coats and sentenced to seven years in Van Diemen's Land. Sarah Welch had, it appears, been affectionately carrying the keepsakes for five years. Nest may have reciprocated the sentiment in the mermaid and intials W. S. tattooed on his right arm. Their union, however, was not to be. Nest married a Van Diemonian in the same year that Welch was arrested.

The when-this-you-see-verse Nest bestowed upon his beloved was often inscribed on love tokens. It probably originated in ancient Rome where words such as 'remember' and 'love me and I will love thee' were inscribed on jewellery. By the fifteenth century, posy rings were being engraved with the English equivalents. In the nineteenth century when-this-you-see verses could be found on a wide array of items such as snuffboxes, embroidery and tableware, but the wording varied depending on context. While the verses were a favourite of those transported to Australia they are almost never mentioned in tattoo descriptions. One exception is Thomas Bligh. Among his tattoos were the names of loved ones, hearts, darts, his trial date, his age and the words:

When this you see
remember me
and bear me in your mind
let all the world say what they will
think of me as you find

Bligh was sentenced to life so it was unlikely that he and the person referred to in his verse would see each other again.

It appears that transported convicts fond of when-this-you-see verses felt they were best left as keepsakes with loved ones. Thomas Lock had a love token inscribed with the verse rather than adding it to his extensive collection of more than fifty tattoos. Sarah Smith had this variation tattooed on her left shoulder:

When this I see
I will remember thee
When thou art—Doom too Stoonery

Smith's verse probably referred to death by stoning. Her tattoo may have eulogised a loved one who was sentenced to death or she may have been referencing another form of condemnation, such as imprisonment or transportation. Tattooed next to Smith's verse was a square composed of four dots for each corner and one dot in the middle, which can symbolise a person oppressed or imprisoned.

William Vincent had no tattoos, but wrote the verse in a letter to his mother. For other convicts, illiteracy might have prevented them from tattooing verses, but Edward Kennedy memorialised his wife with the lines:

Catherine my dear you are my own,
my heart lies in your breast,
although theres many a mile of distant love
and strong seas between us Roar
Constant & true I will prove,
for now & for ever more

Thomas Green's wife died while he was in gaol. He was tattooed with a verse popular among agitators protesting for political reform:

May the Sun never rise on the Palace of a Tyrant
nor set on the Cottage of a Slave

Among the many tattoos on David Roberts's limbs was:

D.J is my Name & England my Nation
oswestry is my Dwelling place and Christ is my Salvation

Roberts's verse was popular, varying according to the bearer's name, birthplace and spiritual belief. A longer version may have resonated with Roberts when he was sentenced to death in 1840. The final stanza reads:

And when I'm dead and in the grave,
And all my bones are rotten
When this you see,
remember me,
Though I am long forgotten.

'WHEN THIS YOU SEE
REMEMBER ME.
WHEN I. AM. FAR FROM THE'

A love token attributed to Thomas Lock, who was transported to Van Diemen's Land in 1845 for highway robbery.

In 1843, Thomas Bligh was discovered hiding in the bedroom of a female convict who was boarding in his master's house. Bligh's predicament casts a rather amusing light on the verse tattooed on his left arm:

> When this you see
> remember me
> and bear me in your mind
> let all the world say what they will
> think of me as you find.

As punishment, Bligh had his ticket-of-leave revoked, was sentenced to three months' hard labour and banished from Hobart Town. The following year, however, he married convict Sarah Bartlett. Bligh and Bartlett had been denied the opportunity when they first petitioned the lieutenant-governor a few months before his bedroom indiscretion. Their request to marry may have been refused because Bartlett was already married—and, although Bligh declared himself single, his tattoos of a woman, the name Phoebe Farmer, a heart and darts, appear to tell a different story.

POLICE No. *1916* 18*33*

DESCRIPTION OF *Thomas Bligh Life*

Transported for House Breaking

Trade *Ploughman*
Height (without shoes) ... *5/6*
Age *23*
Complexion *Fair*
Head *Small*
Hair *Brown*
Whiskers *none*
Visage *Small*
Forehead *Low*
Eyebrows *Brown*
Eyes *L. Grey*
Nose *M.L.*
Mouth *M.W.*
Chin *Straight*
Remarks

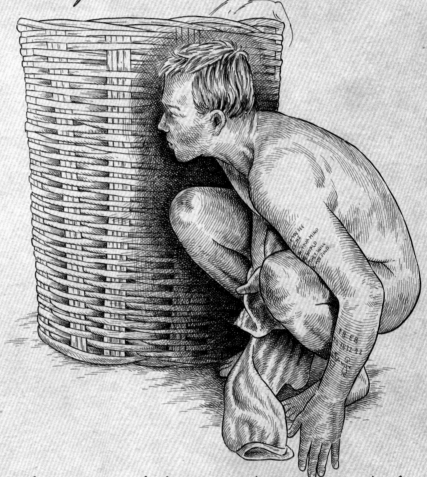

When this you see remember me and bear me in your mind
let all the world say what they will think of me as you find
* T.B. E.B. T.B. 1832 22. flowerpot Woman on left arm*
Health peace & Pleasure Love & Liberty forever
* Woman flowerpot Phoebe Farmer*
* T.B. heart darts & anchor right arm*

HAVING THE LAST WORD

The last convicts transported to Australia arrived at Fremantle, Western Australia, in 1868. But convicted felons continued to be recorded when they entered the prison system, and the process advanced with new technology. Prisoners began to be photographed just as the convict system came to a close in the late 1870s. Photography allowed for a more effective means of identification, but like a written description it wasn't entirely foolproof.

When Tasmanian-born Charles Appleyard was sentenced in 1894 to two years' gaol for housebreaking a photograph was taken as a record of his identity. After his beard and hair were 'close-cropped' for processing, his photograph presented a different portrait.

Even with the availability of photographic records, tattoos continued to be documented, a practice that has extended into the twenty-first century.

Appleyard, was tattooed with the word 'Good', initials, anchors, a wreath and a shamrock. The shamrock reflected his Irish ancestry—his convict mother, Ellen, was born in Ireland. His father, Edward, was English and also a convict. Like his son, he was tattooed with an anchor and his initials. Ellen, too, was tattooed—with two blue dots between her right finger and thumb. The apple, it seems, did not fall far from the tree.

The practice of tattooing didn't end with convicts. Many of their free descendants continued the art. Tattooing was passed from one set of limbs to the next—from one generation to the next—from British born to Australian born. Edward and Ellen Appleyard had eleven children, and some of their descendants have expressed themselves in the same vein: Winston Appleyard, their great-great-grandson, born in 1957, is also tattooed.

Tattoos provide an insight into a person's beliefs, interests, attitude and identity. They also reflect the popular culture of the time. In some cases, such as the kangaroo tattooed on Charles Fever's right arm, and the portrait of Elizabeth Newman that was tattooed next to the words 'my Sheeler' on John Crick, tattoos contributed to the shaping of an Australian identity.

Convict tattoos don't paint a complete picture. It's not possible to know in many cases the particular meaning or significance of a tattoo, or the story behind it. And in some instances the record may not be accurate. The recording process was cursory, prone to mistake and possible mistruth, and many tattoos, even if faithfully transcribed, remain enigmatic.

But even with these constraints, tattoos shed a unique and fascinating light on the eclectic mix of nineteenth-century people who began new lives as convicts in Australia.

Charles Appleyard's entry in the Hobart Gaol record book, 8 June 1896. At this time, razors were prohibited in the gaol. A clean shave had to be sanctioned by the sheriff, and only for 'special cases'. For the duration of their sentences men had their beards and moustaches 'close-cropped'. To ensure recognisability ex-inmates were not permitted to regrow their facial hair until three months after their release. They also had their physical description printed in the *Tasmania Police Gazette*.

Hobart Gaol.

Photo Reg. No. 616

Date 8 · 6 · 96

H. M. GAOL
9 - JUN. 96
HOBART.

Name Charles Appleyard

and Alias

		PARTICULAR MARKS.
When Convicted	23 · 8 · 94	
Where	S. C. Launceston	Cast in left eye. Nose inclined to
Offence	Housebreaking	right. Hair and whiskers slightly
Sentence	2 years	curly. "G.B.D." on inside of right
Date of Discharge	8 · 6 · 96	forearm "Good" on back of right
Native Place	Ross. Tasmania	forearm. "C.A." in wreath on back of
Year of Birth	1866	right wrist. 2 anchors on inside of left
Native Condition	Free	forearm. Shamrock on back of left wrist.
Religion	R.C.	"C.H.A." on back of left forearm.
Education	C.R. or W.	

CRIMINAL HISTORY AND REMARKS.

State	Single	
Height	5 · 6 Weight 9 · 8½	Tasmania
Build	Slight	First Offence

SELECT BIBLIOGRAPHY

Caplan, Jane, (ed.), *Written on the Body: The Tattoo in European and American History*, Reaktion Press, London, 2000.

Dye, Ira, 'The Tattoos of Early American Seafarers, 1796–1818', *Proceedings of the American Philosophical Society*, Vol. 133, No. 4, 1989.

Hood, Susan, *Transcribing Tasmanian Convict Records*, Port Arthur Historic Site Management Authority, 2003.

Keister, Douglas, *Stories in Stone: A Field Guide to Cemetery Symbolism and Iconography*, Gibbs Smith, London, 2004.

Lacassagne, Alexandre, *Les Tatouages: étude AnthroPologique et Medico Légale*, Baillière, Paris, 1881.

Larwood, Jacob & Hotten, John Camden, *The History of Signboards: From the Earliest Times to the Present Day*, Chatto & Windus, London, 1867.

Lombroso, Cesare, *L'uomo delinquente: In rapporto all'antropologia, alla qiurisprudenza ed alle discipline carcerarie*, 5th ed, Turin, 1897.

Maxwell-Stewart, Hamish & Bradley, James, 'Behold the Man: Power, Observation and the Tattooed Convict', *Australian Studies*, Vol. 12, No. 1, 1997.

Maxwell-Stewart, Hamish, 'Collecting by Numbers', *Siglo: Journal for the Arts*, No. 10, 1998.

Redford, Duncan, (ed.), *Maritime History and Identity*, I. B. Tauris, London, 2014.

Schiller, Gertrud, *Iconography of Christian Art*, Lund Humphries, London, 2 v, 1971–1972.

Sill, Gertrude Grace, *A Handbook of Symbols in Christian Art*, Simon & Schuster, New York, 1996.

British Newspaper Archive, britishnewspaperarchive.co.uk

Female Convicts Research Centre, femaleconvicts.org.au

Founders & Survivors Project: Australian Life Courses 1803–1920, foundersandsurvivors.org

Lewis Walpole Library, library.yale.edu/walpole/

National Library of Australia, trove.nla.gov.au

National Museum of Australia, Convict Love Tokens Database, love-tokens.nma.gov.au

Port Arthur Historic Site Management Authority, portarthur.org.au

Queen Victoria Museum and Art Gallery, qvmag.tas.gov.au

Science and Society Picture Library, scienceandsociety.co.uk

Tasmanian Archive and Heritage Office, linc.tas.gov.au

FOR MORE INFORMATION GO TO SIMONBARNARD.COM.AU

PICTURE CREDITS

P. 3, *Mercury*, 5 July 1871, P. 2, Tasmanian Archive and Heritage Office (TAHO). P. 5, Isaac Comer, CON18/1/38, P. 123, TAHO. P. 7, *Regulations for the Penal Settlement at Port Arthur*, H. A. Evans & Son, Melbourne, 1966, author's collection. P. 9, *British Medical Journal*, 4 May 1889, P. 985, State Library of Victoria (SLV). P. 11, William Todd, Journal, June 8 1835–15 November 1835, Manuscript, SLV. P. 13, Lombroso, Cesare, *L'uomo delinquente: In rapporto all'antropologia, alla qiurisprudenza ed alle discipline carcerarie*, Turin, 5th ed, 1897, SLV. P. 21, *Dandy Pickpockets Diving*, Lewis Walpole Library, Yale University. P. 17, Hotten, John, *The Slang Dictionary: Etymological, Historical and Anecdotal*, Chatto & Windus, London, 1874, SLV. P. 19, *An Hieroglyphic Epistle*, Simon Beattie. P. 21, *Punch, or the London Charivari*, No. 698, 25 November 1854, P. 220, author's collection. P. 26, *A Curious Hieroglyphick Bible*, T. Hodgson, London, 11th ed, 1792, P. 7, SLV. P. 27, love token, National Museum of Australia (NMA); human skin, Kings College London (KCL), William Edwards. P. 30, human skin, Science & Society Picture Library (SSPL); love token, NMA. P. 31, cup and saucer, author's collection. P. 35, *The British Beehive*, author's collection. P. 38, *Britannia in Fetters*, Lewis Walpole Library, Yale University. P. 39, *Bank Restriction Note*, author's collection. P. 42, lead seal and snuffbox, author's collection. P. 43, hammer, author's collection. P. 46, love token, NMA; snuffbox, Walpole Antiques, Graham Walpole. P. 47, Graffiti, Bothwell, Tasmania,

author. P. 50, human skin, KCL, William Edwards. P. 51, human skin, SSPL. P. 54, hand brand, SSPL. P. 55, human skin and branding tools, Army Medical Services Museum, Keogh Barracks, England, Graham Cole. P. 59, human skin, SSPL. P. 63, human skin, SSPL; love token, author's collection; locket pin, www.nalfie.com. P. 67, human skin, SSPL; love token, NMA; Scrimshaw tooth, Queen Victoria Museum and Art Gallery (QVM). P. 71, human skin, SSPL; brick and pipe, author's collection. P. 74, love tokens, NMA. P. 75, bobbin, author's collection. P. 78, glass, www.liveauctioneers.com and (the auction house); love token, NMA. P. 79, *Keep Within Compass*, Lewis Walpole Library, Yale University. P. 82, human skin, SSPL. P. 83, love token, NMA; flip-out book, author's collection. P. 86, Staffordshire figure, Lewis Walpole Library, Yale University. P. 87, news clipping, author's collection. P. 90, hand, author. P. 91, rings and box, www.liveauctioneers.com and (the auction house). P.94, love tokens, NMA. P.95, powder horn, QVM. P.98, love token, NMA; rolling pin, author's collection. P.99, lustre mug, author's collection. P.102, ribbon slide, www.nalfie.com. P.103, human skin, SSPL. P.107, love token, NMA; brooch, author's collection; button, Staffordshire Regiment Museum; *A True Lover's Knot*, Fotolibra.com, Malcolm Warrington. P.110, limner print, King's Own Royal Regiment Museum, Lancashire, England. P.111, love token, NMA. P.115, Charles Appleyard, GD128/1/2, P.115, TAHO.

INDEX

ACKNOWLEDGMENTS

Thanks to Lyn and Phil Barnard, Jo Bornemissza, Susan Hood, Brian Rieusset, Chris Wallace-Crabbe, Des Cowely, Bill Edwards, Graham Cole, Jon Addison, Jacek Piotrowski, Denis French, Hermini Rohmursanto, Simon Beattie, Tim Millet, Graham Walpole, Hayden Peters, Jai Paterson, Stephen Smith, Mathew Crowther, Stephen Gapps, Ros and John Hill, Ros and Clive Tilsley, Sophie Lambert, Barry Jessup, Joe Hextall, Jack Callaghan, Cade Butler and family, Duncan Walsh, Winston Appleyard and Tuco. Particular thanks to Hamish Maxwell-Stewart for providing access to data and Anna Felicity Friedman for consultation. Profound thanks to senior editor Jane Pearson, design coordinator Jess Horrocks, publicist Steph Speight, guru Chong, Kirsty Wilson and Shalini Kunahlan and the peerless Text crew. Illimitable thanks to Amélie Mills.